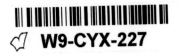
The Milkmaid

by Johannes Vermeer

WALTER LIEDTKE

The Metropolitan Museum of Art, New York

Foreword

"Vermeer's Masterpiece *The Milkmaid*," at The Metropolitan Museum of Art, is one of many events in New York City that celebrate the four-hundredth anniversary of Henry Hudson's journey from Amsterdam to America in 1609, as well as the following centuries of enduring friendship between The Netherlands and the United States. Introducing this publication, which accompanies the exhibition, is a pleasure in which one may take some pride, since it was during the lifetime of Johannes Vermeer, one of the most renowned Dutch painters of the Golden Age, that pioneering settlers in Nieuw Amsterdam, on the tip of Manhattan Island, introduced essential values that remain at the heart of American and Dutch identities: the passion for freedom, the search for opportunities, and commitment to tolerance.

Hundreds of seventeenth-century Dutch paintings are today to be found in museums all across America, impressively illustrating how such great masters as Rembrandt, Vermeer, and Frans Hals were among the first European artists to go beyond the traditional themes of church and state by treating subjects drawn from domestic life and focusing on civic virtues. Hard work, moderation, public service, and love of family were endorsed by the original owners of these pictures and through them and other means passed down to later generations.

No painter surpassed Vermeer in depicting private life during the first decades of Dutch independence and, as it happens, the founding years of Nieuw Amsterdam and New York. His fascination with light combined with his acute observation in general evokes the new Age of Exploration and at the same time reveals the crucial contribution of personal experience. This was the world that Henry Hudson left behind when sailing to new shores four hundred years ago, the same world that Vermeer saw and visualized with his particular sense of style and his innovative use of color and light.

For bringing one of Vermeer's most famous paintings to New York on this commemorative occasion, I congratulate Thomas Campbell, Director of the Metropolitan Museum, Walter Liedtke, Curator of European Paintings at the Metropolitan, and Wim Pijbes, Director of the Rijksmuseum, Amsterdam, as well as their staffs on their achievement.

Frans Timmermans
*Minister for European Affairs of the
Kingdom of The Netherlands and
Government Coordinator for NY400*

This publication is issued in conjunction with the exhibition "Vermeer's Masterpiece *The Milkmaid*," held at The Metropolitan Museum of Art, New York, from September 9 to November 29, 2009.

The exhibition is made possible by the William Randolph Hearst Foundation, Daphne Recanati Kaplan and Thomas S. Kaplan, and Bernard and Louise Palitz.

Published by The Metropolitan Museum of Art, New York
John P. O'Neill, Publisher and Editor in Chief; Gwen Roginsky, General Manager of Publications; Margaret Rennolds Chace, Managing Editor; Emily Radin Walter, Senior Editor; Bruce Campbell, Designer; Peter Antony, Chief Production Manager, assisted by Anjali Pala

Typeset in Dante MT Std; printed on Perigord 170 gsm; color separations by Professional Graphics, Inc., Rockford, Illinois, and Die Keure, Bruges
Printed and bound by Die Keure, Bruges

Cover: Johannes Vermeer (1632–1675), *The Milkmaid*, ca. 1657–58. Rijksmuseum, Amsterdam (detail)

Cataloging-in-Publication Data is available from the Library of Congress ISBN 978-1-58839-344-9

Director's Note

The Milkmaid, by the celebrated Delft master Johannes Vermeer (1632–1675), is one of the most admired paintings in the world and an image especially beloved in The Netherlands. Already described as famous in 1719, the small canvas is now such a familiar symbol of Dutch culture that simply announcing its name to a native of the country—in Dutch (*Het Melkmeisje*) or even in English—will probably conjure up a clear mental picture of the composition as well as memories of a visit to the Rijksmuseum in Amsterdam or a particular day in school. There are paintings that could be said to offer a broader view of seventeenth-century Dutch society, such as Rembrandt's *Night Watch* (1642) or *Syndics of the Cloth Guild* (1662), since they represent the kinds of civic organizations that transformed The Netherlands into an independent republic and a business empire. But in *The Milkmaid* we discover Dutch self-reliance and well-being in an individual who appears to have her own thoughts and feelings but also evokes the hard-won peace and prosperity of the Golden Age.

However one might explain the painting's significance and associations, its loan from the Rijksmuseum to the Metropolitan Museum, from Amsterdam to New York, and from The Netherlands to the United States is an extraordinary gesture that comes from the heart and reflects centuries of international friendship.

The immediate occasion is the four-hundredth anniversary of the arrival of a Dutch ship at an island then known locally—that is, to the Lenni Lenape natives—as Mannahatta. It was in the second week of September 1609 that the *Halve Maen (Half Moon)*, an eighty-ton ship with a crew of twenty Dutch and English sailors, entered the mouth of the river that was later named for the ship's captain, Henry Hudson. In 1607 and again in 1608, Hudson, on behalf of a London trading company, had attempted to find a "northwest passage" between the Atlantic and Pacific oceans, and thus between Europe and the Far East. In 1609 he made his third attempt, this time in the employ of the Amsterdam chamber of the East India Company. Near present-day Albany it became obvious to Hudson that a shortcut to China was not to be found, but his exploration did lead to the subsequent founding of the Dutch colony Nieuw-Nederland (New Netherland) about 1624. In that year thirty families were settled on Governors Island, and soon thereafter they moved to the tip of Manhattan Island. Fort Amsterdam was built at that location, and around it the port and town of Nieuw Amsterdam spread northward to a fortified wall (along which ran Wall Street). Nieuw Amsterdam flourished as a Dutch settlement until 1664, when it was captured by the English and renamed New York.

The rest of the story requires no rehearsal here, although it might be emphasized that an important aspect of Dutch-American relations during the next three hundred years was the preference for Dutch paintings among American collectors. American museums, and preeminently the Metropolitan Museum, are now home to hundreds of great Dutch paintings dating from the seventeenth century, including thirteen of the thirty-six known works by Vermeer. Five of his pictures are owned by the Metropolitan and are included in the present exhibition, while three paintings by Vermeer may be seen nearby at The Frick Collection.

Nearly half of Vermeer's surviving oeuvre was seen at the National Gallery of Art, Washington, in the exhibition "Johannes Vermeer" of 1995–96. A similarly large but somewhat different selection of paintings by Vermeer was included, along with about 140 other works of art, in the Metropolitan's 2001 exhibition "Vermeer and the Delft School." *The Milkmaid*, however, has been to America only once before, when it was one of the "masterpieces of art" displayed at the New York World's Fair of 1939–40.

"Vermeer's Masterpiece *The Milkmaid*" is one of several events celebrating the anniversary of Hudson's voyage in 1609. In that respect the exhibition recalls the Museum's participation in the citywide Hudson-Fulton Celebration of 1909, when 149 seventeenth-century Dutch paintings (including five Vermeers) and a large display of American pictures and decorative arts were gathered from private collections and public institutions in this country. The essence of the current project, less ambitious perhaps but of very special import, is the gift of a loan, for nearly three months, of one precious Dutch picture, as a gesture of collegiality between two great museums and two great countries.

Walter Liedtke, Curator of European Paintings and the author of the present publication, was mainly responsible for ensuring that the Hudson anniversary was commemorated by the Museum and for working with our friends at the Rijksmuseum. We are especially thankful to the Rijksmuseum's new director, Wim Pijbes, and to Taco Dibbits, Director of Collections, and Pieter Roelofs, Curator of Seventeenth-Century Painting. Indispensable assistance was eagerly provided by the Consul General of The Netherlands in New York, H. Gajus Scheltema, by General Director for Cultural Affairs USA, Ferdinand Dorsman, and by the Minister for European Affairs and coordinator for the Dutch Government of the NY400 celebrations, Frans Timmermans. We are also extremely grateful to HRH the Prince of Orange for his gracious support.

Finally, I would like to extend my warm thanks to Daphne and Tom Kaplan and to Bernard and Louise Palitz, whose generosity together with the William Randolph Hearst Foundation made this exhibition possible.

Thomas P. Campbell
Director
The Metropolitan Museum of Art

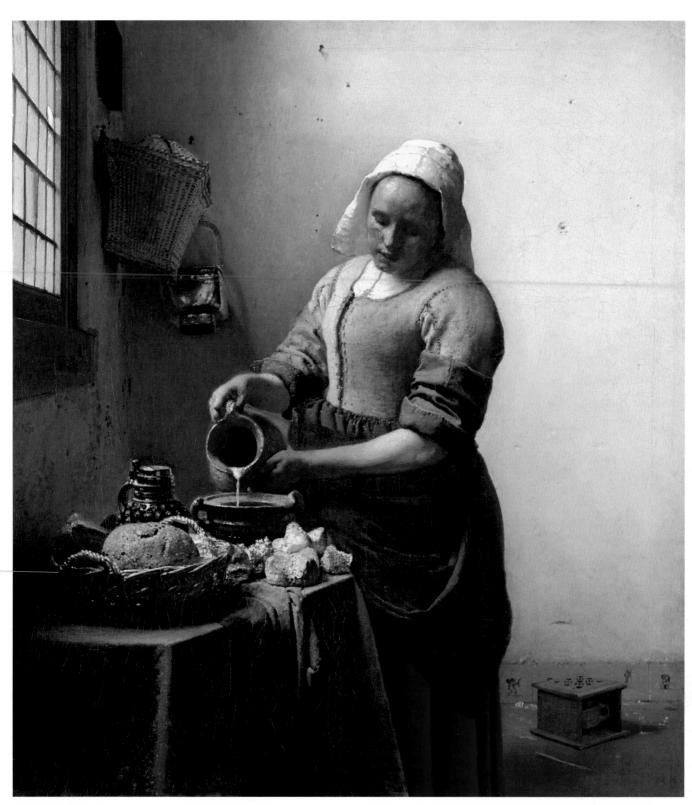

Johannes Vermeer (1632–1675). *The Milkmaid*, ca. 1657–58. Oil on canvas, 18 × 16⅛ in. (45.5 × 41 cm). Rijksmuseum, Amsterdam

The *Milkmaid* by Johannes Vermeer

"The famous Milkmaid, by Vermeer of Delft, artful."
Van Hoek sale, Amsterdam, April 12, 1719

The Milkmaid was painted about 1657–58, when the artist, Johannes Vermeer (1632–1675), was approximately twenty-five years old and as yet little known, except to his fellow painters and perhaps to a few art dealers and collectors in his native Delft. The canvas is fairly small, only 18 inches high by 16⅛ inches wide (45.5 × 41 cm); its comparatively intimate scale has often surprised the many visitors who have sought the picture out in the meandering galleries of the Rijksmuseum in Amsterdam.

Such a famous work might be expected to loom large in the imagination, but there are other, more objective reasons that the painting is often assumed to be or is even remembered as larger than it is. For instance, the sturdy figure of a kitchen maid—she is not specifically a milkmaid, although for the moment (and forever) she is pouring milk—is modeled in a sculptural manner that is somewhat inconsistent with Vermeer's usual approach. Viewers who have marveled at the painter's evocations of natural light and atmosphere, and the sort of "optical" effects that occur more pervasively in later pictures such as the *Young Woman with a Water Pitcher* (Pl. 7), will discover quite different qualities here, despite the astonishing treatment of sunlight on the sparkling still life in the foreground, in the hazy window (with a small break in the glass revealing the intensity of light outside; see detail on page 10), and on the whitewashed walls. The receding wall on the left remains in shadow and is marked by stains and flaking paint, suggesting that it is often rather damp and cool to the touch. The other wall is bathed in light from the window and is seen parallel to the picture plane, with which its subtly textured surface might almost be confused in the brightest areas. However, the transition from the shadowy corner (which wonderfully sets off the objects on the table and the woman's right hand) to the brilliant wall plane behind the woman and to the right and a variety of surface incidents lend substance to the wall and (with the floor and foot warmer to the lower right) clarify its location in space. Two nails stick out from the surface, one just above the hanging basket and another (casting a triangular shadow) at top center (see detail on page 22). At least two nail holes, other specks and indentations, and stains and discolored whitewash mark the plaster and the passage of time.

The most palpable impressions of substance and texture are found in the figure and in the arrangement of objects in front of her. Vermeer evokes the feel, the shapes, and even the

1. Attributed to Gerrit Dou, *A Young Woman Fetching Water from a Well*, ca. 1650–55. Oil on wood, 11¼ × 8½ in. (28.5 × 21.5 cm). Kunstsammlung Basel, Bequest Max Geldner, Basel, 1958

construction of the linen cap, the woolen jacket, the shoved-up work sleeves (which are separate sleeves worn over those of the jacket itself), the heavy red columnar skirt, and the blue apron that has been pulled up around her ample hips.[1] Smooth and rough surfaces are compared in the fabrics on the table, the blue stoneware jug, the earthenware vessels, the wicker basket, and the crusty breads. The maid's high, rounded brow, strong features, and weathered forearms seem almost carved in wood, so rugged and emphatic are their simple shapes.

Thus solid and tactile forms are massed together, placed within a clear and expansive space. This approach lends a certain grandeur to the subject, an arresting presence that transcends the coy illusionism found in comparable pictures by Gerrit Dou (fig. 1). (One cannot imagine a figure by Dou

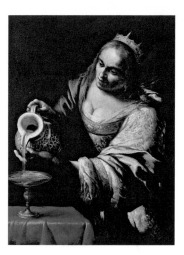

2. Domenico Fiasella, *Artemisia*, ca. 1645. Oil on canvas, 40 × 30 in. (101.6 × 76.2 cm). Private collection (photo courtesy the National Gallery of Art, Washington, D.C.)

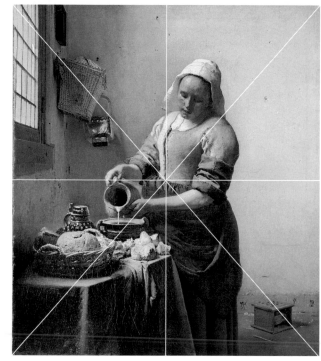

3. Diagram of axes through the center of *The Milkmaid*

greatly enlarged or transformed into a freestanding sculpture, as Vermeer's milkmaid and her table have been on a street in Delft).[2]

But another, perhaps more compelling reason for the figure's imposing, "heroic" (as it has been described), monumental presence is that Vermeer designed the composition to make precisely this impression.[3] Those who assume that the model, the objects, the corner of space, and lighting conditions were actually in front of the artist during the two or three months such a painting would have been on his easel have usually not considered its carefully resolved artistic effects, let alone its many references to works by other masters and the technical demands of preparing pigments and oils, applying layers of paint, allowing them to dry between working sessions (which might have been separated by days), revising parts of the composition, and so on. We will return to some of these questions below.

Aspects of the Composition

The self-contained figure of the milkmaid, with her stocky proportions and firmly grounded pose (in Greece she could be a caryatid), creates an impression of reliability and steadfastness. One writer has gone so far as to claim that this household servant "conveys a physical and moral presence unequaled by any other figure in Dutch art."[4] This might be considered rather overstated praise if *The Milkmaid* is compared with Rembrandt's slightly earlier *Aristotle with a Bust of Homer* (1653; Metropolitan Museum of Art). Such a comparison, however, serves to demonstrate that the presentation of Vermeer's figure—with its counterpoise between the raised and lowered arm (see also the *Young Woman with a Water*

Pitcher; Pl. 7), between the figure and the table with objects, between these motifs and the picture field, and perhaps even between action and contemplation—reveals the taste of a particular period which favored classical forms and the values they reflect, such as dignity and constancy.

Of course, such values are suggested by the milkmaid alone: with different dress and attributes, she could easily be transformed into an allegorical figure (Fortitude or Temperance, for instance), a mythological personage (see fig. 22), a biblical character (like Martha, serving bread, in fig. 23), or a heroine of ancient times (see fig. 2).[5] However, if the Delft painter's protagonist were set into a Leiden-style picture by an artist such as Frans van Mieris or his master Dou (see fig. 1), she would hardly have the same effect.

In addition to strong modeling, Vermeer has used what might be described as solid and plane geometry to make the figure appear formidable. Simply shaped objects are placed in a stepped progression from the front of the table to the basket and bowl and to the figure's lower arm, and thence to the swelling volumes of her body. Her skirt meets the table like a bastion in a city wall, with green and red folds plunging to the ground like buttresses. The architectural effect is softened by bolts of blue cloth that spill from sunlight to shadow by the bread basket and by the apron, which hangs in broad swags (it seems) from the corners of the table as well as the woman's waist.

In two-dimensional terms, the ensemble of table and maid forms a right triangle set somewhat off-center in the composition and counterbalanced by the L-shaped bracket of the left-hand wall and the floor. The diagonal thrust to the right is also parried by the woman's three-quarter pose and by the objects that descend from the upper left corner (window

mullions, framed picture, basket, and pail) through the figure to the foot warmer. The maid, in mild contrapposto, with slanting shoulders and tilting head, is supported mainly on her right leg as she leans slightly forward balancing the pitcher. Most likely it was intuition rather than calculation that led Vermeer to place the figure's center of gravity in the approximate center of the picture field (see fig. 3), an arrangement that quietly enhances the impression of equipoise. The woman's arms and the areas of her head and hands—the viewer's two centers of attention—are placed above and below and to either side of invisible center lines, which lends to the picture a sense of harmony that has often been termed "timeless." It is, of course, nothing of the sort, but an idealized view of domestic life that is specific to its time and place and especially characteristic of this extraordinarily gifted painter.

Another kind of geometry, that of linear perspective, was first employed confidently by Vermeer about 1657, in *The Letter Reader* (Gemäldegalerie Alte Meister, Dresden; fig. 4) and in the *Cavalier and Young Woman* (Frick Collection, New York; fig. 5). The comparatively distant and delicate figure of the letter reader is seen somewhat from above, the horizon coincident with the middle of her high forehead and the window receding to a point well behind her, to the right.[6] In the Frick canvas, the viewer's eye level is the same as the woman's and the window recedes to a central vanishing point about two-thirds the distance between her face and the man's nose.[7] Thus the presumably male viewer of *The Letter Reader* and the suitor in the courtship scene both look slightly downward at the objects of their affection. This is hardly the case in *The Milkmaid*, where the window recedes to a point just above the hand holding the pitcher and where a pinhole in the canvas may be found. Here and in at least sixteen other canvases by Vermeer there is physical evidence that he employed the traditional studio shortcut of sticking a pin into the support and stretching a string to intervals at the side or bottom of the composition in order to locate orthogonal lines (fig. 6).[8] In effect, the low vantage point in *The Milkmaid* sits the viewer down in a chair on the near side of the table, his face on a level with the pitcher. Thus the bulky torso of the kitchen maid rises well above his head. If her face were seen from slightly above, her downcast eyes might be interpreted as a sign of modesty or servitude (as in figs. 4, 22, 23). But here the woman's glance suggests concentration and control.

That Vermeer had a fondness for geometry is evident in the interplay of lines and planes in a painting such as *The Glass of Wine*, of about 1658–59 (Gemäldegalerie, Staatliche Museen zu Berlin), or in the composition of *Young Woman with a Water Pitcher* (Pl. 7), which resembles a cone set within rectangles. But there is more to Vermeer's sense of design than Euclidean niceties. His pictures, however naturalistic, however seemingly

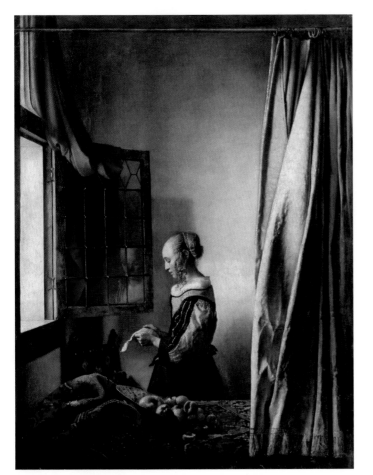

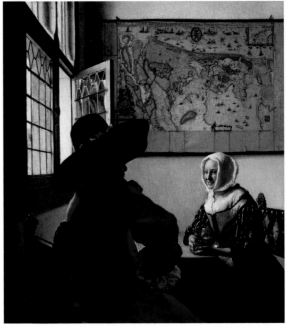

4. Johannes Vermeer, *The Letter Reader (Young Woman Reading a Letter)*, ca. 1657. Oil on canvas, 32¾ × 25¼ in. (83 × 64.5 cm). Gemäldegalerie Alte Meister, Staatliche Kunstsammlungen, Dresden

5. Johannes Vermeer, *Cavalier and Young Woman*, ca. 1657. Oil on canvas, 19⅞ × 18⅛ in. (50.5 × 46 cm). The Frick Collection, New York

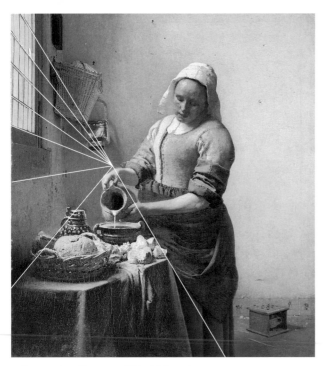

6. Perspective diagram of *The Milkmaid*

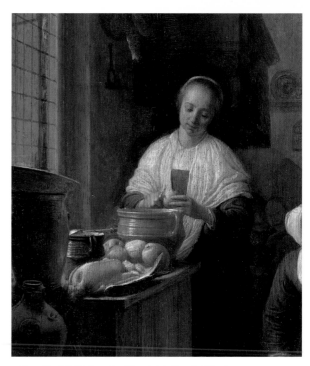

7. Detail of *A Kitchen*, by Hendrick Sorgh (Pl. 5)

caught in a glance (or in some kind of recording device),[9] reveal countless formal refinements. We might observe, for example, that the miraculous orchestration of light, tonal values, and colors in *The Milkmaid*, with its infinite nuances, is based on two simple systems: the use of primary colors—red, blue, and yellow—and one secondary mixture, green, both in the figure and in the still life; and a complementary scheme of alternating light and shadow, so that from foreground to background we find shallow zones of space proceeding from dark to light to dark (for instance, at the front edge of the table) and from light to dark to light (the bread, the sides of the jug and bowl, the pitcher and arms, and so on). This sort of layering in depth was recommended by the painter and critic Karel van Mander already in 1604, but here attains a complexity heretofore unknown.[10] The tonal sequence comes to an end with the transitions of light and shadow behind the figure, whose left contour is set against a fading field of gray and whose right contour is silhouetted against the radiant off-white surface of the sunlit wall. Arthur Wheelock has noted that Vermeer also painted a fine white line along the entire right contour of the kitchen maid (see detail opposite), thereby heightening the contrast between figure and ground to make her near side appear to advance.[11]

Another preoccupation in Vermeer's work is the sympathetic relationship of contours and shapes. Round, rectangular, cubical, and elliptical objects (here, all the containers and the foot warmer) echo each other; lines curving downward (as in the cap, shoulders, and hand) find some corresponding parenthesis; forms with no obvious connection are weighed against each other in the artist's scale (the windowsill and the floor; the round loaf of bread and the woman's bulging brow). The outline of an arm rhythmically answers another, and intervals between forms seem measured by some optical sense of decorum. Here, the long left contour of the figure descends from head to hand in a cautiously graceful manner, continues in a faster sequence of curves leading from her highlighted fingers to the mouth and body of the pitcher, to the rim and left handle of the bowl, and to the trio of handle-bread-handle in the basket. It is less immediately apparent that the figure's left contour is also compared with the brisk cascade of curves and sudden descents described by the outlines of the hanging basket, the copper pail, and the pail's extended shadow on the wall. Like cataracts on either side of a gorge these lines lead down to a grotto and basin where a thin stream finally falls.

Artistic conceits of this kind are typical of Vermeer and occasionally become more obvious and often more exquisite in later pictures. The visual predisposition that made him such a remarkable observer of light effects was complemented by a prodigious memory for formal ideas found in the work of other painters. For example, the idea of cropping a detail from a composition by Dou or some other living artist, such as Hendrick Sorgh (fig. 7 and Pl. 5), so that it gave new life to the type of kitchen scenes (with robust maids) that had been painted by Pieter Aertsen and Frans Snyders (fig. 8) was probably for Vermeer a matter of closing his eyes and remembering.[12] However, the still-life passages in those earlier interiors favor picturesque disarray. This did not suit Vermeer's

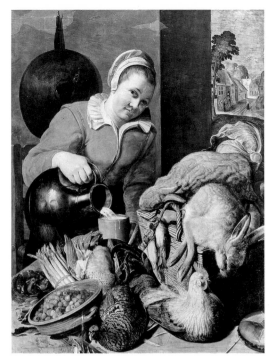

8. Attributed to Frans Snyders, *A Kitchen Maid Pouring Milk*, ca. 1630. Oil on canvas, 49⅝ × 38¼ in. (126 × 97 cm). Musées Royaux des Beaux-Arts de Belgique, Brussels

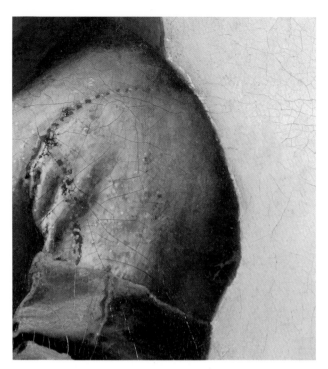

Detail of *The Milkmaid*: the figure's near shoulder

temperament, and in *The Milkmaid* one senses that he had studied still lifes proper, perhaps of the "monochrome banquet" variety, with their carefully calculated compositions. The lateral progression of similar shapes (basket and bowl) and the use of one standing vessel as a visual anchor recall Haarlem specialists such as Willem Claesz Heda and Pieter Claesz. Heda in particular liked to play with circles and ovals in different planes: the bottom of a tazza touching the rim of a plate (as in fig. 9) and similar displays of pictorial cleverness. Vermeer does something analogous with the pitcher and bowl, but he makes the encounter less conspicuous and somehow more significant, as if meaning not milk were being transferred from one vessel to another.

Subject and Content

Despite its seemingly straightforward subject *The Milkmaid* has been variously interpreted, especially in recent years. As noted above, the figure has been described as heroic, with a "moral presence" not found elsewhere in Dutch art. "Her stature is enhanced by the wholesomeness of her endeavor: the providing of life-sustaining food." In this interpretation, the nobility of labor is underscored by the servant's "rugged, rough-hewn character," which seems "at home in this simple room" with its humble imperfections ("pitted, bare walls") and absence of embellishment ("aside from the pail and marketing basket hanging on the wall, little here distracts from the focus of her concerns").[13] Thus Vermeer's milkmaid is a city cousin of the kneeling countrywoman in *The Wheat Sifters*, by Gustave Courbet (Musée des Beaux-Arts, Nantes), and the

striding peasant in *The Sower*, by Jean-François Millet (Museum of Fine Arts, Boston).

A more prosaic reading along the same lines concludes that the milkmaid is making bread pudding, "although the artist has chosen not to show us the egg shells, sugar, and other condiments" that would have been used. He does show us a "small warmer," which is mistaken for a primitive space heater with a "feeble radiance." This is taken as evidence (as if Dutch paintings were like archaeological digs) that the home depicted in *The Milkmaid* was not "rich enough to boast two kitchens"—a cooking kitchen and a "cold kitchen"—but only one which "is being kept cold to facilitate working with doughs and custards."[14]

9. Willem Claesz Heda, *Still Life with Oysters, a Silver Tazza, and Glassware*, 1635. Oil on wood, 19⅝ × 31¾ in. (49.8 × 80.6 cm). The Metropolitan Museum of Art, From the Collection of Rita and Frits Markus, Bequest of Rita Markus, 2005 2005.331.4

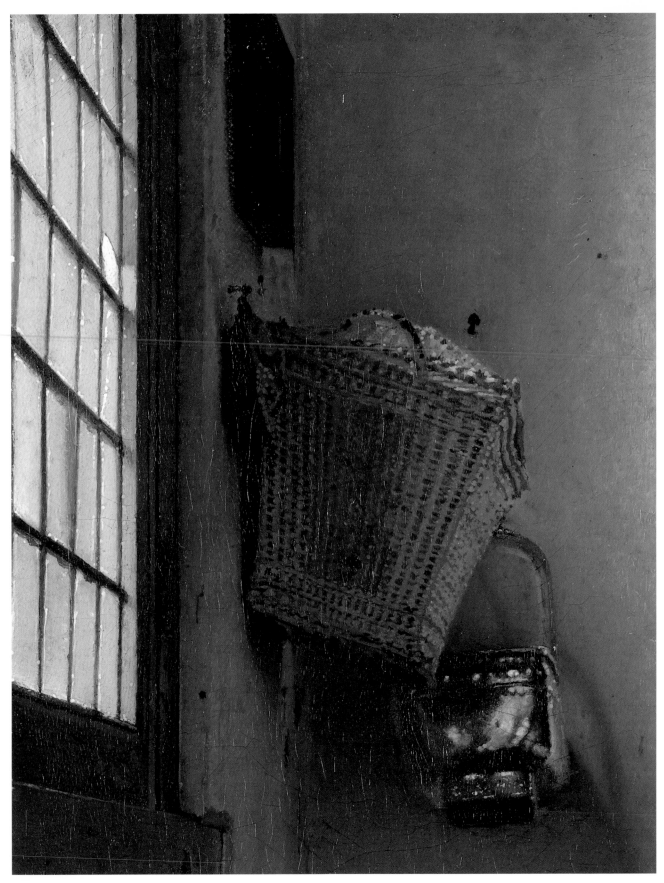

Detail of *The Milkmaid*: window, basket, and pail on wall

As it happens, we know about the kitchens in the house owned by Vermeer's mother-in-law, where the painter and his family lived from about 1654–55 onward.[15] The residence on the Oude Langendijk in the center of Delft featured an "interior kitchen" in which ten paintings, a sideboard, and two foot warmers could be found; a "cooking kitchen," which in addition to a fireplace had a bed with lots of bedding, a coatrack, a small table, six old chairs, and a small chair for a child; a "little back kitchen," where an iron grill, a pewter colander, and similar objects were stored; and a "washing kitchen," with two spinning wheels and a cradle.[16] Despite these conveniences, much of the bread (the mainstay of the Dutch diet at the time) that was consumed by the painter's growing family appears to have been purchased rather than made at home. At his death in December 1675, Vermeer owed the master baker Hendrick van Buyten 617.3 guilders—enough money to support a middle-class family for about a year—for past deliveries of bread. A month later his widow turned over two pictures by Vermeer as collateral.[17]

In the most recent commentary on the subject, it is considered "odd, really, that this obvious interpretation of what the maid is doing" (making bread pudding) was proposed only recently and has not attracted much notice.[18] "Is she not just standing in a cold pantry (which would explain the small foot-warmer in the lower right corner)" making bread pudding, for which (it is now claimed) "all the ingredients are on the table." Furthermore, "there could be beer in the tankard, which was often used to make bread pudding rise," even more bread in the hanging basket ("out of the reach of mice"), and the copper pail "could have been used for taking delivery of the milk." Such a transaction is said to be precisely what we see in paintings by Nicolaes Maes, but in fact his door-to-door saleswomen carry large round copper cans (like the one in fig. 10) and their customers take delivery in earthenware bowls like the one in *The Milkmaid*.[19] Other pictures by Maes make it clear that copper pails were used for bringing fish and fowl home from the market.[20]

It goes without saying that Vermeer's maid is doing something useful: this is a genre scene not an allegory (like Pl. 10). The suggestion that bread pudding (or, more accurately, bread porridge) is being made would be consistent with the large amount of bread (some of which must be stale) and the pouring of milk. But Vermeer resists literal interpretation and, as is noted often, suspends narrative. For this artist, a painting of a maid concerns not only what she is doing but also her character and feelings, the viewer's response, the artist's powers of observation, and his patron's appreciation that the rarest of pictures is in his hands.

Part of the patron's pleasure in the painting would have been seeing familiar objects so faithfully described. In a stroll through the market he would have encountered many metal pails (they were not always made of copper), with long handles allowing them to hang over the arm. Such *marktemmers*

10. Nicolaes Maes, *Rustic Lovers*, ca. 1658–59. Oil on wood, 27½ × 35½ in. (69.8 × 90.3 cm). Philadelphia Museum of Art, John G. Johnson Collection, 1917

(market buckets) and *visemmers* (fish pails) are commonly seen in paintings by Maes, Gabriël Metsu, Quirijn van Brekelenkam, and other Dutch artists. Vermeer's model is smaller than most, square (they are usually round), and more finely detailed. Next to the pail is a covered basket, and above that a picture in a black frame. The two-handled bowl or pot and the pitcher are examples of redware, which in this period was mostly produced in the town of Oosterhout in North Brabant. The stoneware beer jug with a pewter lid and a cobalt blue glaze came from the Westerwald region of the Rhineland, southeast of the Netherlands.[21]

As for the table, its shape would have been better understood by viewers of the day than it has been by critics who have questioned the artist's use of perspective. This must be a gateleg table that, when open, has an octagonal top.[22] The edge of the table, seen as a small wedge of green above the piece of bread to the right (see detail on page 12), is parallel to the long side against the wall (and therefore recedes to the vanishing point; see fig. 6). Between the bread just next to the bowl and the right side of the bowl is a triangular patch of red (the maid's skirt) above a smaller glimpse of green. In other words, the maid stands against the diagonal side of the table. This sort of slicing, dicing, and overlapping (often of receding lines) is common in later works by Vermeer but here it is more complicated than usual, in part to ease the transition from the angles of the table to the curves of the figure.

Perhaps it was also in deference to perspective—making objects recede properly—that the painter described the bread-basket in the round before placing loaves into it (in an infrared reflectogram, fig. 11, the dark loaf of bread on the left is barely discernible and the rim of the basket is more complete). Pentimenti are also evident in the maid's lower arm and a few other areas.[23] And there are two major changes. In the reflectogram (fig. 12) a large rectangular object is seen on or

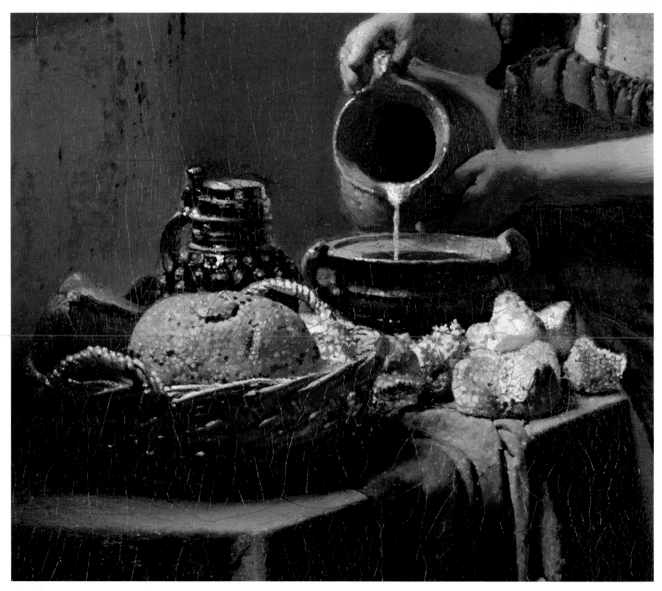

Detail of *The Milkmaid*: the breadbasket

against the wall behind the maid. Its horizontal form suggests that it may have been a mantelpiece.[24] Also visible in the reflectogram, on the floor to the right, is a large basket of clothes. For this corner of the composition, the foot warmer and the row of Delft tiles were Vermeer's second thoughts.[25]

Wheelock and Dibbits offer mainly formal explanations for these substantial revisions, which achieved "a greater feeling of space," or clarity and balance of design.[26] It is true that with large objects to the right the composition would be somewhat cluttered and perhaps ungainly. But as in other paintings, Vermeer must also have been swapping motifs in order to modify meaning. In an earlier stage of *The Letter Reader* (fig. 4), for example, a large *roemer* (drinking glass) stood in the right foreground, where the curtain had not yet appeared, and a large painting of a standing Cupid hung on the back wall.[27] *A Maid Asleep* (Pl. 6) once included a man in the second room and a large dog in the near doorway looking

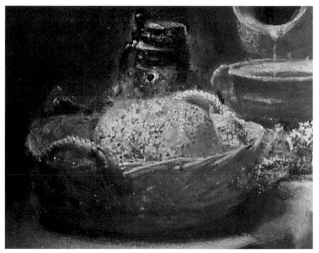

11. Detail of *The Milkmaid*: the breadbasket as seen in the infrared reflectogram (fig. 12)

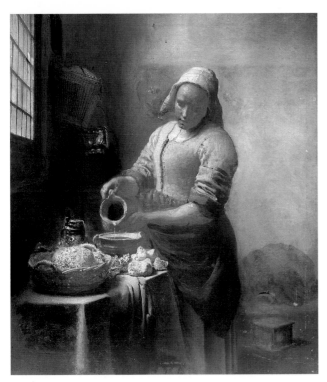

12. Infrared reflectogram of *The Milkmaid* (© Stichting RKD, The Hague)

back at him.[28] In both paintings (which are nearly contemporary with *The Milkmaid*) these and other passages of repainting resulted in much subtler interpretations of romantic themes.

A basket of clothes, destined for washing, sewing, or needlework, is occasionally found in Dutch genre scenes involving courtship, such as Jacob van Loo's *Wooing*, of the early 1650s (fig. 13), and Vermeer's small canvas *The Love Letter*, of about 1669–70 (Rijksmuseum, Amsterdam). Duty and desire are at odds in these pictures: in amatory texts of the time, maids and mistresses alike are distracted from their daily tasks by dreams or offers of love. One illustration in a popular emblem book of 1644 shows Cupid handing a songbook to a smiling young lady who sets her sewing aside (fig. 14). In the painting on the wall behind her, a man stands on the shoreline of a choppy sea (for such is love). The emblem, according to the title at the top, is about "Young women who love and have no sense," and its *subscriptio* (the explanatory verse below) speaks for the woman: "My duty requires me to work, but Love will not allow me any rest. I do not feel like doing anything . . . ," and so on in the same vein.[29]

Perhaps some object or image in the earlier state of *The Milkmaid* implied amorous diversion from housework. In any event, by inserting a foot warmer and, next to it, a Delft tile depicting Cupid (see detail on page 14 and fig. 15), Vermeer intimates that love and desire, as well as work, are burdens the maid must bear.[30] Foot warmers do not heat rooms: they heat feet and, under a long skirt (as in Van Loo's *Wooing*), more private parts. The tile to the right of the foot warmer represents a

man with a long walking stick or staff. Is someone expected (as in the *Woman with a Lute*, Pl. 8), or remembered after he has gone away (as in *A Maid Asleep*, Pl. 6)? It may be significant that the corners of the foot warmer's perforated top seem to point at the Cupid and the male figure (both of which are presented in profile) and that the design on the last tile to the right appears to be intentionally indecipherable. A bright piece of plaster or some other white substance on the floor below the Cupid catches the viewer's attention, and a straw in front of the foot warmer draws our gaze into the same pocket of space. Cupid's advancing figure, with bow brandished (toward the man?), is also made more conspicuous by his blue color, which resonates with the apron hanging nearby.

To the modern eye these details may seem almost too slight to mention, but they would have been recognized by some viewers of the period as appropriate footnotes to the usual story of milkmaids and kitchen maids. Long before Maes and Vermeer turned to the theme, artists exploited the reputation of kitchen maids and especially milkmaids for sexual availability. This is implicit in Lucas van Leyden's engraving *The Milkmaid*, of 1510 (fig. 16), where the strapping lad with a staff and the buxom lass seem keenly aware of each other. The cowherd's (and the viewer's) focus on the farm girl would have brought to mind the slang word *melken* (to milk), meaning to attract or lure.[31] One commentary on the term's origin is offered in the anonymous *Nova poemata* (subtitled "New Low German Poems and Riddles"), of 1624. A crude print of a maid milking a cow and chatting with a passing

13. Jacob van Loo, *Wooing*, early 1650s. Oil on canvas, 28⅞ × 26¼ in. (73.3 × 66.8 cm). Mauritshuis, The Hague

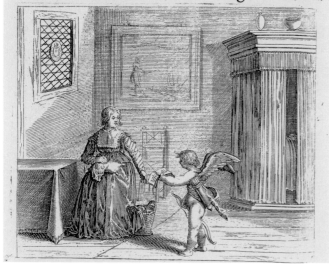

Vrijſters die minnen „ en hebben geen zinnen.

14. *Cupid Presenting a Songbook to a Young Woman*, an emblem in Jan Harmensz Krul, *Pampiere Wereld* (Amsterdam, 1644). Koninklijke Bibliotheek, The Hague

15. Delft tile depicting Cupid, late 17th century. Collection of Mr. and Mrs. H. Rodney Nevitt Jr.

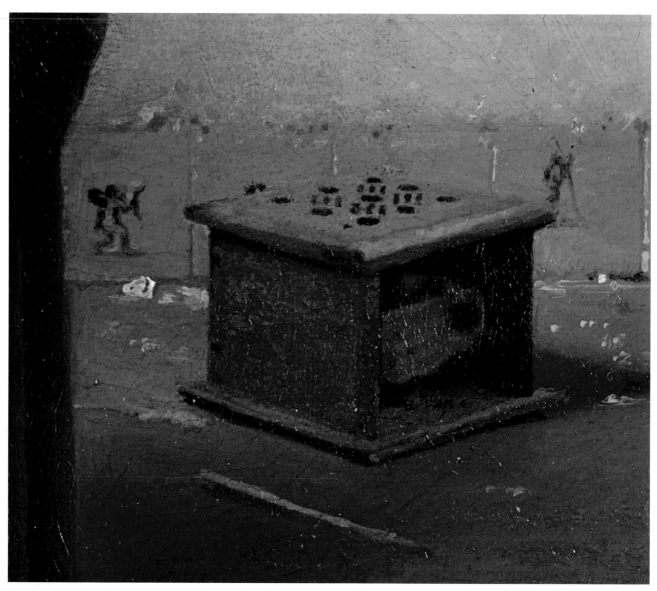

Detail of *The Milkmaid*: the foot warmer and Delft tiles

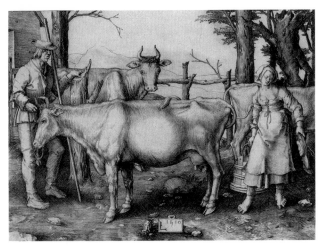

16. Lucas van Leyden, *The Milkmaid*, 1510. Engraving, 4½ × 6⅛ in. (11.4 × 15.5 cm). The Metropolitan Museum of Art, Gift of Felix Warburg and his family, 1941 41.1.24

17. Andries Stock after Jacques de Gheyn II, *The Archer and the Milkmaid*, ca. 1610. Engraving, 16¼ × 12⅞ in. (41.4 × 32.8 cm). The Metropolitan Museum of Art, The Elisha Whittelsey Collection, The Elisha Whittelsey Fund, 1949 49.95.1331

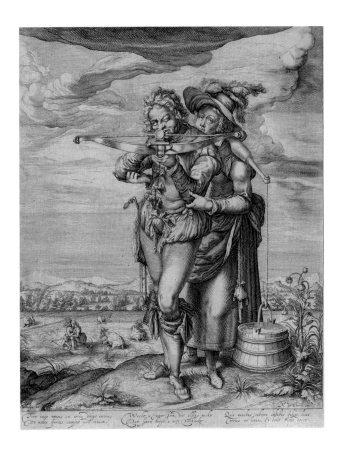

stranger (he wears city clothes and leans on a walking stick) is accompanied by the verse:

> A sinewy thing she has seized with joy
> And strokes it up and down for a long time,
> Til with a squeeze she makes a very sweet sap run out
> Which she puts in a hole between her legs.[32]

When a well-bred artist like Jacques de Gheyn touched on the same subject it was usually with more circumspection, if that is the word for his image of an archer with a bulging codpiece and a milkmaid (wearing his hat) who lends a hand (fig. 17). De Gheyn alludes to "milking" and "shooting your bolt" (ejaculation) and perhaps even to "birding" (copulation), since the crossbow is loaded with a bolt used for hunting birds. At the same time he recalls Cupid shooting his arrows, some contemporary illustrations of which are inscribed "Amor vincit omnia" (Love conquers all). By the cows in the left background the archer fondles the milkmaid, and a stallion (one assumes) ogles what must be a mare. The inscriptions are not very revealing, except for the way they implicate the viewer. In the Latin text the milkmaid tells the archer to "hit what is swollen squarely," but the Dutch verse in the center warns maidens about men with crossbows cocked.[33]

In Rembrandt's erotic etching *The Monk in the Cornfield*, of about 1646, a milkmaid (whose copper can has been set aside) supinely supports the supposed celibate's missionary position.

The print is about monks not milkmaids: the prelate simply knew where to sow wild oats.[34]

Kitchen maids are far more common than milkmaids in Netherlandish art, where they attract the same sort of attention from visiting farmhands and the occasional gentleman. Vermeer must have known many paintings in the tradition of Pieter Aertsen, Joachim Beuckelaer, and their numerous emulators, including Joachim and Peter Wtewael in Utrecht and Cornelis Delff and Pieter van Rijck in Delft. The large canvas by the younger Wtewael in the Metropolitan Museum is typical in its overdone innuendo (fig. 18): a country boy with a big basket of eggs (testifying to his virility) offers his bird to a comely cook. She responds by jamming a chicken onto a spit, one of several signs in the picture of carnal knowledge and intercourse.[35] What is most interesting for Vermeer's painting of a kitchen maid (apart from the physical type) is the jug held open in the young man's hand and his extended middle finger. Like many other motifs in the picture, such as the mortar poked by the pestle to the left, a jug presented in a certain way—open, tipped forward, or seen with something phallic or a winning smile—was a well-known reference to distaff anatomy.

Most of the motifs found in Wtewael's painting were already common in market and kitchen scenes by Beuckelaer, as seen in his set of large canvases, *The Four Elements*, of 1569–70 (National Gallery, London). Fecundity and sensuality are the dominant themes, but in *The Element of Air* (fig. 19) the young man's offer of birds is met with stiff poses and stern expressions, suggesting that what he has to offer will be firmly

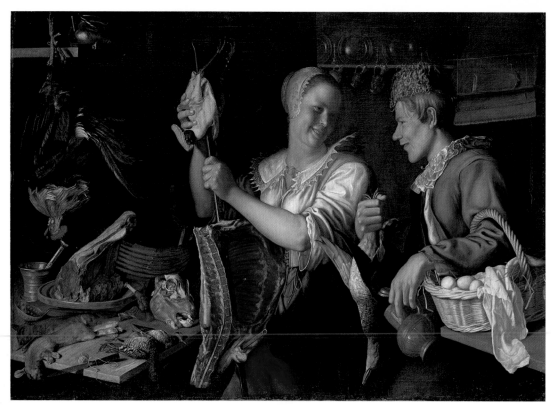

18. Peter Wtewael, *Kitchen Scene*, 1620s. Oil on canvas, 44¾ × 63 in. (113.7 × 160 cm). The Metropolitan Museum of Art, Rogers Fund, 1906 06.288

19. Joachim Beuckelaer, *The Element of Air (A Poultry Market)*, 1570. Oil on canvas, 62¼ × 84⅝ in. (158 × 215 cm). The National Gallery, London

20. Drawing after a misericord of ca. 1530 in the Church of Ste. Materne, Walcourt, Belgium (from Louis Maeterlinck, *Le genre satirique, fantastique et licencieux . . .* [Paris, 1910])

21. Jacob Backer, *A Young Woman with a Jug*, ca. 1645. Black and white chalk on blue paper, 14⅜ × 9⅞ in. (36.6 × 25.2 cm). Maida and George Abrams Collection (photo courtesy the Museum of Fine Arts, Boston)

declined. The heroine of the composition is the attractive young maid to the left, who by holding a bird and covering the mouth of a milk can—together with her upright posture and sober glance at the viewer—conveys her determination to remain virtuous.[36]

In a number of pictures by Dou, Van Mieris, and other Leiden contemporaries of Vermeer, an attractive young woman holds a jug (often tipped forward) and acknowledges the viewer in a friendly way. (In the Basel Dou, fig. 1, one sign of a male response is the tall object on the left: a yoke for milk pails, which is rarely seen erect, as here). In modern times a symbol other than a jug would have to do, but in the seventeenth century the analogy between the female sex organ and a jug or round bottle was endorsed by doctors as well as popular writers and several generations of artists.[37] Near the beginning of this development—and at the nadir of taste—is a Flemish misericord of about 1530 (fig. 20) that shows a peasant exposing himself while chasing a smiling maiden who holds her jug in a suggestive way. Compared with this wood carving (placed beneath a choir seat!) and pornographic prints of the period, Flemish paintings of kitchen maids (fig. 8) and their Dutch counterparts (fig. 18) seem almost understated. But they are far more obvious in meaning than the later Leiden pictures of servant girls (fig. 1), which benefited from the theme's familiarity while moving toward more polite interpretations. Whether Jacob Backer's beautiful drawing of a young maid with a jug (fig. 21) was intended to be seen as quietly erotic as well as charming is hard to say. Backer did other studies of maids from life, but this one is more carefully finished and clearly intended as an independent work.

Vermeer went even further in the direction of obliquity than any of his Leiden colleagues. Much as he would edit himself (Cupid and the beer glass deleted from *The Letter Reader*; the man and dog dropped from *A Maid Asleep*), the Delft painter would tone down the symbols, situations, winks, and smiles seen in the work of other artists (with the possible exception of Gerard ter Borch, whose temperament seems sympathetic to Vermeer's). Consequently his pictures are allusive rather than explanatory, visual poetry rather than prose.

In this transformation the visual, or "optical," factor should not be underestimated. Vermeer had an extraordinary ability to combine and revise artistic sources, so that one scarcely recognizes the connection between his invention and its prototypes. His own disposition and his background in Delft (known for its staid society) encouraged the artist to pare away whatever seemed unnecessary, of which he found much in Mannerist and Leiden school pictures. At the same time his fascination with light and with direct observation was both personal and a Delft development. This broader context will be discussed briefly below, but what it means for *The Milkmaid* is that something well worn in Dutch art (like an old shoe) has become something never seen before (like a glass slipper). The impression made by the picture in terms of space and light is so naturalistic that its artifice simply falls away. The kitchen, the maid, and the ordinary objects are for a moment made beautiful by light pouring in through the window and by a seemingly accidental harmony of shapes and colors.

The physical appeal of the "milkmaid" is sensed naturally, too, like the taste of milk or the touch of bread. Rough sleeves reveal bare arms, where the skin (unlike that of the wrists and hands) is rarely exposed to sunlight. The ruddy wrists and face, the woman's generous proportions, and her warmth, softness, and approachability are qualities not found in Vermeer's more refined young ladies. They too are alluring, but the kitchen maid is frankly so.

The psychological nuances in this picture find no parallel in earlier paintings of milkmaids, kitchen maids, and comparable figures. But elsewhere in Vermeer's oeuvre there are clear parallels. The (intended) male viewer feels temptation and restraint, desire and reservation.

This conflict—the self-consciousness of the voyeur—is encouraged both by Vermeer's treatment of the subject and by his choice of style. In this, his most Leidenesque painting, the artist creates an enthralling illusion of reality. But the painting's small scale and technical virtuosity reveal that the little world before us is nothing other than a deception—as are any thoughts, any self-deceptions, about intimacy with the maid, in contrast to the maids of Wtewael, Dou, and so on. It is likely that, while the viewer entertains ideas about her, the young woman is thinking of another. The earlier and present objects in the right background hint in that direction, and it is also what we discover in *The Letter Reader* (the missive is not from the viewer; fig. 4) and in *A Maid Asleep* (Pl. 6). Vermeer raises the question of what is on the maid's mind. However the answer is not only impossible to know but beside the point, which is that the viewer wonders what the woman thinks and feels (not an impulse one has with Wtewael or Dou). She may be desired, but she is also understood, like Callisto, Martha, the undutiful maid, and the letter reader in Vermeer's earlier paintings (see figs. 22, 23, Pl. 6, and fig. 4), each of them with downcast eyes and busy imaginations. In the artist's sympathetic view these women are all slightly guilty and at the same time entirely innocent.

Seeing Vermeer's kitchen maid in this light may be unfamiliar, even for specialists, because romantic encounters between a gentleman and a servant are rarely if ever seen in Dutch art.[38] Nevertheless, they are frequently implied: the viewer of single-figure pictures such as those by Dou (fig. 1) is not assumed to be the social equal of the young lady depicted but the owner of the painting or one of his peers. In literature of the period, and occasionally in legal cases, illicit relations between maids and their masters are considered a threat to domestic harmony, or even the social order.[39] And "proper" gentlemen of the period, perhaps especially those who were only passing through, certainly wandered into kitchens and other back rooms, hoping to seize an opportunity. In his famous diary Samuel Pepys confides that on a visit to Delft (the entry is dated May 19, 1660) a friend took him "to a Du[t]ch house [an inn] where there was an exceedingly pretty lass and right for the sport; but it being Saturday

[a busy day, presumably] we could not have much of her company."[40] This is one of many instances in which Pepys recorded for his own pleasure some sally toward a waitress, maid, or (recalling Steen) "oyster girl." *The Milkmaid*, however, sets a very different tone from that of Pepys's diary and elicits responses more complicated than those which could have been expected by Dou.

When musing in this manner about Vermeer's meaning and the viewer he envisioned (whether a specific person or a type of client), we assume that they were both rather sensitive or at least thoughtful individuals. The next section briefly considers the first owner of *The Milkmaid* and other early works by Vermeer.

Vermeer's Early Work and Principal Patron

When *The Milkmaid* was sold in an Amsterdam auction on May 16, 1696, along with twenty other paintings by Vermeer and works by other artists, it was described as a picture of "A Maid who pours Milk, exceptionally good, by ditto [J. van der Meer]"; and the winning bid was 175 guilders. This was the second highest price of the day. Vermeer's great cityscape painting, *A View of Delft* (Mauritshuis, The Hague), brought 200 guilders, and the *Woman with a Balance* (National Gallery of Art, Washington, D.C.), listed as "A Young Woman who weighs gold, in a case by J. van der Meer of Delft, extraordinarily artful and vigorously painted," sold for 155 guilders. The other genre paintings by Vermeer in the sale fetched about half or one-third as much: 80 guilders for *The Music Lesson* (Royal Collection, Windsor and London), 62 guilders for *A Maid Asleep* (Pl. 6), and 44 guilders for the *Cavalier and Young Woman* (fig. 5).[41]

22. Johannes Vermeer, *Diana and Her Companions*, ca. 1653–54. Oil on canvas, 38½ × 41⅛ in. (97.8 × 104.6 cm). Mauritshuis, The Hague

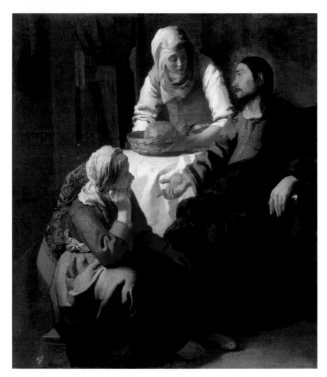

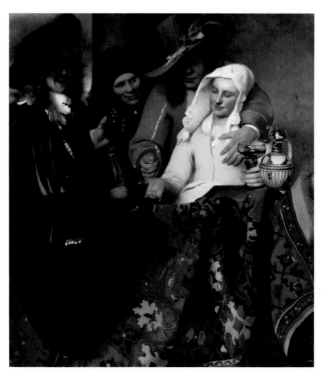

23. Johannes Vermeer, *Christ in the House of Mary and Martha*, ca. 1654–55. Oil on canvas, 63 × 55⅞ in. (160 × 142 cm). National Gallery of Scotland, Edinburgh

24. Johannes Vermeer, *The Procuress*, 1656. Oil on canvas, 56¼ × 51⅛ in. (143 × 130 cm). Gemäldegalerie Alte Meister, Staatliche Kunstsammlungen, Dresden

The twenty-one paintings by Vermeer and several other pictures in the sale came from the estate of Jacob Dissius (1653–1695), a Delft printer and bookbinder of good family but modest means. Twenty paintings said to be by Vermeer and probably one other work by him (the artist's name was simply omitted) were listed, without any description of their subjects, in April 1683 as left to Dissius by his late wife, Magdalena van Ruijven. When she died, on June 16, 1682, Dissius had to borrow money to pay for the funeral, but as the childless Magdalena's universal heir he inherited the domain of Spalant, near Schiedam (purchased in 1669 by Pieter van Ruijven, Magdalena's father, for 16,000 guilders); numerous interest-bearing notes in the name of Magdalena's mother, Maria (d. 1681); the rental income from a house on the Voorstraat, one of the best addresses in Delft; and thirty-nine pictures, including twenty or, more likely, twenty-one paintings by Vermeer.[42]

Pieter Claesz van Ruijven (1624–1674), later Lord of Spalant, married the wealthy Maria de Knuijt in 1653. They moved into The Golden Eagle, a house on the Oude Delft, the city's most prestigious street. In 1671 the house was appraised at 10,500 guilders. Van Ruijven appears to have had no occupation other than managing his investments. From 1668 to 1672 he served as master of the municipal chamber of charity, but as a Remonstrant (a liberal Protestant sect) he was excluded from the higher civic offices in which he would otherwise probably have served.

On November 30, 1657, Van Ruijven lent Vermeer and his wife 200 guilders, to be repaid (plus 4½ percent interest) within a year or court action would be taken. There is no known record of repayment or legal difficulties. To the contrary, when the Van Ruijvens drew up a will in 1665 they promised "to Johannes Vermeer Painter 500 guilders," an exceptional gesture considering that every other beneficiary named in the document was a relative or a charity. John Michael Montias, who first made the connection between Dissius and Van Ruijven, suggested that the loan of 200 guilders to Vermeer in 1657 was actually an advance on payment for his work. This is entirely plausible, considering that three paintings by Vermeer dating from about 1657–58—*A Maid Asleep* (Pl. 6), the *Cavalier and Young Woman* (fig. 5), and *The Milkmaid*—were inherited by Van Ruijven's only surviving child, Magdalena.

There is really no document comparable to the will of 1665, in which a nonroyal patron provides for the immediate future of an artist after his death. Van Ruijven, however, probably knew of another Dutch painter's enjoyment of something like princely patronage. In the 1630s and 1640s Pieter Spiering "Silvercroon," son of the great tapestry weaver François Spiering, paid Gerrit Dou 500 guilders per annum to secure some of his best works for the Swedish court.[43] Spiering was the son of Van Ruijven's great-aunt (his mother's first cousin) and also his sister Pieternella's godfather. Perhaps, as Montias proposed, Van Ruijven, on the model of Spiering's relationship with Dou, maintained "a sort of right of first

refusal" with Vermeer.[44] Van Ruijven would also have been aware of princely patronage much closer to home, at the neighboring court city of The Hague (many Delft artists had supplied pictures and other luxury goods to the Princes of Orange). By having his own "court painter," Van Ruijven was behaving to the manor born well before he became a lord. This stature did not prevent Van Ruijven from crossing Delft on the night of February 11, 1670, to assist Vermeer's sister Gertruy and her husband, the framemaker Anthony van der Wiel. Evidently Vermeer's mother had just died (she was buried two days later), and the new will required a witness "well known" (as the notary recorded) to the heirs.

An important question about Van Ruijven's relationship with Vermeer is whether he was responsible for turning the painter to the subject of modern life. Three of the four earliest known genre scenes by Vermeer—*The Letter Reader* (fig. 4) is the exception—were probably acquired by the patron not long after they were completed. In his earlier works, Vermeer (who joined the Delft painters' guild December 29, 1653) aspired to the higher status of a history painter and experimented with styles that were favored at the Dutch court. As a mythological picture with a hunting theme, *Diana and Her Companions* (fig. 22) could hardly have been more expected of a young painter living near The Hague and the prince's palace at Rijswijck.[45] The composition recalls Diana paintings by Jacob van Loo, but in *Christ in the House of Mary and Martha* (fig. 23) Vermeer sets his sights higher, combining qualities reminiscent of the Utrecht artist Hendrick ter Brugghen (the type and strong modeling of Mary in the foreground and the light throughout) with fluid brushwork and rhythmic contours apparently inspired by Anthony van Dyck and the other Flemish masters (in particular, Thomas Willeboirts Bosschaert) who had recently worked for Prince Frederick Hendrick.

The Procuress, dated 1656 (fig. 24), adopts the model of Gerrit van Honthorst and other Utrecht masters who were favored by the prince and his adviser, Constantijn Huygens. In this regard, Vermeer also could be said to have followed the Delft Caravaggesque painter Christiaen van Couwenbergh. But the probable self-portrait (as a carefree rake) and other passages of remarkable description and light effects (the tankard and glass, and the costumes of the client and "working girl") are in accord with a new generation of painters in Delft (especially Carel Fabritius). In the lace-trimmed hood of the young woman (who is probably a waitress with experience in other services), the piping on the coin dropper's sleeve, and the ribbon on his hat, there are tentative anticipations of the pointillé scheme that Vermeer would use so effusively to suggest scintillating light in the still life (and less conspicuously in the blue apron and elsewhere) in *The Milkmaid*. If one doubts that the jug in that painting is suggestive, the vulgar arrangement of the glass and lute neck in *The Procuress* might be pointed out. But there is no comparison in terms of discretion.[46]

Of course the subject of *The Procuress* is a "drollery," with roots in Rome and the Netherlandish past.[47] Scenes of modern manners, by contrast, were newly fashionable in the 1650s, when the Dutch Republic was enjoying hard-won peace and prosperity, and when painters such as Ter Borch and Maes (see Pls. 1, 3) were introducing fresh ideas. Vermeer is not known to have had a formal teacher, and his sweeping survey of artistic styles in the 1650s is consistent with the notion that he essentially taught himself.[48]

The influence of Maes has often been noted in *A Maid Asleep* (Pl. 6) and that of Ter Borch in the figure in *The Letter Reader* (fig. 4). Vermeer signed a document in Delft with Ter Borch on April 22, 1653, and he obviously admired the older artist's style, subjects, and sensibility (both painters appear to have benefited from close exposure to the private worlds of women). But by about 1657 Vermeer was absorbing lessons from a good number of Dutch genre painters, including Dou and Van Mieris in Leiden and Pieter de Hooch in Delft. The left-corner scheme of presenting interior space, a convention that Vermeer and De Hooch used repeatedly from about 1657 onward (see Pl. 2), went back to earlier decades in the South Holland region (as seen in Sorgh; Pl. 5) but was given new intensity and illusionistic force by bringing the viewer closer to the scene and devoting unprecedented attention to naturalistic effects of light, space, and atmosphere. There are many parallels to this development in other cities of the Netherlands and even elsewhere in Europe, but in Delft during the first half of the 1650s several factors, including coincidence, brought together a circle of painters—Fabritius, De Hooch, Emanuel de Witte (see Pl. 12), Gerard Houckgeest, and Hendrick van Vliet (see Pl. 11), among others—who shared a keen interest in direct observation and in describing their immediate urban environment.

What all of this suggests about Van Ruijven's relationship with Vermeer is that he certainly did not determine the artist's shift to domestic themes any more than he influenced his distinctive style. Nevertheless, he was an astute collector and the first and most important patron to recognize the painter's astonishing talent. Furthermore, he provided the opportunity for Vermeer to work at or near the uppermost level of the market for works of this kind, as did Dou and Van Mieris but not Maes or even Ter Borch. To some extent Vermeer's very high standard of execution, aspects of his subject matter (courtship and the private lives of women), and the prevalence of certain motifs in his mature pictures (there were, for example, no musical instruments in Vermeer's house) must reflect Van Ruijven's interest and support.

As for the finer points of painting per se, Van Ruijven would have delighted in Vermeer's illusionism and perhaps in what modern critics describe as his optical effects. But he would not have viewed a picture such as *The Milkmaid* with the eyes of an artist, someone like the Delft still-life painter Willem van Aelst, who often used a stipple technique—tiny

dots of paint—to suggest sun glittering on the silk fringe of fancy drapery, as Vermeer does at the bottom of the curtain (and on the piled-up carpet) in *The Letter Reader* (fig. 4).[49] Van Mieris in 1658 employed a similar pattern to highlight the folds in a young lady's elegant sleeve.[50] Vermeer, however, saw that this pointillé pattern could also suggest the grainy surface of bread and the roughness of wicker baskets at the same time that it emulated dazzling daylight. He would later sprinkle these tiny reflections about like salt: on the shadowy sides of boats (where they make artistic not optical sense) in *A View of Delft*, or schematically on the tapestry (suggesting its weave) in the *Allegory of the Catholic Faith* (Pl. 10). The blurred touches of white on silk or satin fabric in the *Study of a Young Woman* (Pl. 9) are analogous in their arbitrary placement but achieve a very different effect.

Also striking is the difference in description between the milkmaid's face and that of Vermeer's visages of intriguing young women painted five or ten years later. If *The Milkmaid* is the artist's most Leidenesque picture, although it is utterly transformed into the idiom of Delft, then the *Young Woman with a Water Pitcher* (Pl. 7) is a mature work in which he has left the trace of artistic sources behind. The later picture reveals very different choices: as if in a vision, not a real space, a figure floats in sunlight before the screenlike surface of a whitewashed wall. She herself is a fiction, an ideal woman in an ideal home. By contrast, the figure in *The Milkmaid*, though idealized in her own way, is a real woman. The model was perhaps a real person, even a kitchen maid. But it was through the artist's invention that she became a character of the imagination and ultimately an archetype of Dutch life.

Later Owners of *The Milkmaid*

The 1696 sale of paintings from the estate of Jacob Dissius, son-in-law of Vermeer's Delft patron Pieter Claesz van Ruijven, was described at the beginning of the previous section. Twenty-one pictures by Vermeer were among the works sold at that extraordinary auction in Amsterdam, and the first two lots, the *Woman with a Balance* (now in Washington) and then *The Milkmaid*, sold for 155 and 175 guilders (fl.), respectively. As noted above, only *A View of Delft* (lot 31) brought a higher bid (fl. 200). The two genre paintings were both acquired by the Mennonite merchant and amateur artist Isaac Rooleeuw (ca. 1650–1710), who must have hung them in his house on the Nieuwendijk in Amsterdam, just off the Dam (Main Square) in the heart of the city. Rooleeuw went bankrupt five years later, and at the Amsterdam foreclosure sale of April 20, 1701, the *Woman with a Balance* was sold for fl. 113 to the merchant and bibliophile Paulo van Uchelen, and *The Milkmaid* ("A milk pourer by the same") went for fl. 320 to Jacob van Hoek (1671–1718), a merchant with a house on the Keizersgracht.[51]

In Van Hoek's estate sale, held in Amsterdam on April 12, 1719, no. 20 was described as "The famous *Milkmaid*, by Vermeer of Delft, artful" ("Het vermaerde Melkmeysje, door Vermeer van Delft, konstig"); it sold for fl. 126. Van Hoek also owned Gerrit Dou's most ambitious work, a large triptych representing the learning of art (through natural-born talent, education, and practice). The original was lost at sea in 1771 on its way to Catherine the Great of Russia, but a copy was made by Willem Joseph Laquy (1738–1798; Rijksmuseum, Amsterdam). The immediate fate of *The Milkmaid* after the Van Hoek sale is not known, but at some later date it entered the collection of another Amsterdam merchant, Pieter Leendert de Neufville (ca. 1706–1759). His collection was inherited by his son, Leendert Pieter de Neufville (1729–d. after 1774), who went bankrupt in 1765. At the forced sale on June 19, 1765, *The Milkmaid* (no. 65, "powerful in light and brown [meaning chiaroscuro], and strong in effect") sold for fl. 560 to the art dealer Pieter Yver.

The next known record of the canvas is in the Dulong sale, held in Amsterdam on April 18, 1768, which was run by Yver's son Jan and Hendrik de Winter. It went to Van Diemen (presumably an agent) for fl. 925. By 1781, when Sir Joshua Reynolds saw the painting in Amsterdam, it was owned by the wealthy banker Jan Jacob de Bruyn (1720–1792). His collection was sold six years after his death, in Amsterdam, September 12, 1798, when *The Milkmaid* ("one of the most beautiful [works] by this inimitable Master") was acquired for fl. 1,550 by the dealer and draftsman J. Spaan. Spaan was probably acting for Hendrik Muilman (1743–1812), who like De Bruyn was an Amsterdam banker. In an Amsterdam sale of July 16, 1792, *The Lacemaker* by Vermeer (Musée du Louvre, Paris) was sold to Spaan and then went into Muilman's collection. Muilman's pictures were auctioned on April 12, 1813, in his house on the Herengracht.

The next step in the provenance is rather refreshing. At the Muilman sale the painting of the kitchen maid was purchased (through the dealer Jeronimo de Vries) for fl. 2,125 by one of the great women collectors of Dutch art, Lucretia Johanna van Winter (1785–1845). Van Winter's pursuit of superb pictures was given a considerable head start when in 1807 she and her younger sister Annelies each inherited half of their father Pieter de Winter's famous collection. Among the works he left to Lucretia were *The Little Street*, by Vermeer (Rijksmuseum, Amsterdam), and probably the finest picture that Bartholomeus Breenbergh ever painted, *The Preaching of John the Baptist*, of 1634, in the Metropolitan Museum.

In 1822 Lucretia married Hendrik Six van Hillegom, who also came from a distinguished family of collectors. Van Hillegom outlived his wife by two years, and in 1847 their sons, Jan Pieter Six van Hillegom and Pieter Hendrik Six van Vromade, inherited the entire Six van Hillegom–Van Winter collection. Gradually they sold it off, but the two Vermeers stayed with them until their deaths in 1899 and 1905.[52] During the second half of the nineteenth century, thousands of visitors saw the paintings by Vermeer, as well as Rembrandt's great portrait of Jan Six (1654), in the family's town house on the Amstel.

25. Two political cartoons by Jan Rinke, *Het Vaderland*, November 9, 1907. Uncle Sam threatens to abduct Vermeer's milkmaid, but Minister of the Interior P. Rink saves the lady (who suddenly becomes better looking) with an infusion of government funds.

The Six heirs intended to auction off about sixty of the remaining pictures, including *The Milkmaid*. However, the Vereniging Rembrandt (Rembrandt Society), a foundation established in 1883 to support important acquisitions by Dutch museums, approached the Six family in an attempt to retain the painting for the nation. The heirs insisted on a package deal: the Vermeer and thirty-eight other paintings in the collection could be sold to the society for 750,000 guilders. The offer was accepted, but only 200,000 guilders could be raised from private donors. In 1907 the society asked the Dutch government to make up the difference, which brought the matter into the roaring arena of public debate. The young connoisseur Frits Lugt published a pamphlet (September 1907) arguing against the transaction, ranking *The Little Street* higher, and maintaining that the perceived threat from wealthy American collectors was exaggerated. This brought an immediate blast from one of the biggest guns in the art game, Abraham Bredius, who as an eminent art historian, wealthy collector, and director of the Mauritshuis in The Hague had been advising the government to settle with the Six heirs. In his letter to the newspaper *Het Vaderland* (September 18, 1907), Bredius accused Lugt of vested interest (he worked for an auction house) and claimed

that "one of the greatest American collectors" was ready to pounce. In a matter of days the name of J. Pierpont Morgan was being tossed about. Morgan was a plausible candidate, since he had purchased *A Lady Writing* by Vermeer (National Gallery of Art, Washington, D.C.) in the same year, supposedly without having heard of the artist previously. Rival politicians, art critics, and cartoonists questioned each other's intelligence, motives, and patriotism, but in the end the purchase was approved by a large majority of the Dutch parliament. In January 1908, *The Milkmaid* and its thirty-eight companions from the Six collection went to the Rijksmuseum.[53]

Despite Uncle Sam's seductive efforts (as seen in fig. 25) and frequent entreaties from American museums, *The Milkmaid* has been in the United States only once before, from 1939 to 1941. Lent to "Masterpieces of Art," an exhibition organized by Wilhelm R. Valentiner, it was part of the spectacular New York World's Fair of 1939–40, which was open from April through October for two years. On May 10, 1940, Germany invaded the Netherlands. Between seasons and after the fair closed, on October 27, 1940, *The Milkmaid* was seen in "masterpiece" exhibitions at the Detroit Institute of Arts, where Valentiner was director from 1924 to 1945. Valentiner had also been a curator at the Metropolitan Museum, from 1908 until 1914, and he organized the Museum's exhibition of 149 seventeenth-century Dutch paintings that formed part of New York City's Hudson-Fulton Celebration of 1909. The present exhibition is part of a citywide celebration of the four-hundredth anniversary of Henry Hudson's sail, on behalf of the Amsterdam chamber of the East India Company, up the river that bears his name. One would like to claim credit for bringing *The Milkmaid* back to New York on this festive occasion. But it is a much greater pleasure to recognize that the Rijksmuseum chose the picture as a fitting tribute to Dutch–American friendship, a gesture from one great museum to another, from Amsterdam to New York (formerly Nieuw Amsterdam), and from the Netherlands to the United States. For those four hundred years and these eighty-two days we are most grateful.

Detail of *The Milkmaid*: the nail at top center

1. Work sleeves of this kind (separate sleeves made of wool or heavy silk) were called *morsmouwen*, or "mess sleeves" (*morsen* means to make a mess, to spill something). The costume historian Marieke de Winkel (personal communication, June 2009) kindly explained this article of clothing and noted also that aprons worn by maids — unlike the white aprons worn by ladies of the house — were often dark blue to mask stains. Blue aprons are seen on the servants in Vermeer's *Mistress and Maid*, of about 1666–67 (Frick Collection, New York), and in *A Lady Writing a Letter with Her Maid*, of about 1670–71 (National Gallery of Ireland, Dublin).

2. A life-size version of Vermeer's heroine was made from concrete and stucco in 1975 by Wim Schippers, and stands by the Binnenwatersloot in Delft at the corner of the Westvest.

3. The image is described as heroic and in similar terms by Arthur Wheelock in Washington–The Hague 1995–96, p. 108.

4. Ibid., where the term "steadfastness" is applied to the figure's "gaze as she measures the flow of milk."

5. The comparison to the Genoese artist Domenico Fiasella's *Artemisia* was first suggested by Jørgen Wadum, who assumed that Vermeer knew the painting (see Washington–The Hague 1995–96, p. 110). Such a direct connection seems unlikely. In Wheelock 1995, pp. 63–64, the viewer of *The Milkmaid* is advised to "think of [the painting] as allegory . . . conceived to convey an abstract concept . . . not a genre scene." Compare also the composition of Felice Ficherelli's *Saint Praxedis*, also of about 1645 (Collection Fergnani, Ferrara). As is well known, a copy of Ficherelli's canvas has been attributed to Vermeer (see Washington–The Hague 1995–96, pp. 86–87, no. 1, where both versions are illustrated), but the repetition is probably by the Florentine painter himself. These comparisons illustrate how stylistic conventions, including patterns of composition, circulated widely in Europe.

6. See Wadum in Washington–The Hague 1995–96, p. 73, fig. 10, for a perspective diagram.

7. Ibid., p. 70, fig. 5a.

8. Ibid., pp. 67–69, fig. 4; and personal communication from Jørgen Wadum, July 6, 2009.

9. For Vermeer's possible interest in the camera obscura and the great deal that he did not owe to it, see appendix A in Liedtke 2008.

10. See Van Mander 1604, fol. 35v. On the use of light and shadow to create a sense of depth in the still life, see also Dibbits 2007, p. 7.

11. See Wheelock 1995, p. 65, fig. 45, where it is concluded that "the pattern of light falling into the room is illogical."

12. The painting attributed to Snyders was previously ascribed to Samuel Hofmann (ca. 1596–1648) and earlier catalogued as "Flemish School."

13. The quotations are from Wheelock's entry in Washington–The Hague 1995–96, p. 108.

14. Rand 1998, p. 350. The author is Senior Curator of Cultural History at the Smithsonian Institution, National Museum of American History, Washington, D.C.

15. See Liedtke 2008, pp. 17–20, on the house and its contents, and the question of when Vermeer and his new wife would have moved in.

16. Montias 1989, doc. 364, the inventory (dated February 29, 1676) of Vermeer's estate and the contents of his mother-in-law's house.

17. Ibid., doc. 361.

18. Dibbits 2007, p. 5, for this and the following quotations. Rand's article (1998) was overlooked in New York–London 2001, no. 68, but is cited in Liedtke 2008, p. 76.

19. See Krempel 2000, nos. D 10 and D 22, figs. 35 and 37 (the Ascott canvas of ca. 1655 and the Apsley House, London, picture of ca. 1656).

20. Ibid., nos. A 38 (fowl), D 20 and D 44 (fish), figs. 53, 56, and 57 (all ca. 1659).

21. Information about redware from Oosterhout, copper pails, Westerwald jugs, and bread porridge was kindly supplied in June 2009 by Alexandra Gaba-van Dongen, curator at the Museum Boijmans Van Beuningen, Rotterdam, in consultation with the Delft archaeologist Epko Bult and other specialists.

22. See Dibbits 2007, p. 6, fig. 10. Dibbits illustrates a seventeenth-century Dutch gateleg table with an octagonal top, half of which folds on top of the other half (personal communication from Taco Dibbits, July 2009).

23. See Wheelock 1995, p. 67, on the basket and the left sleeve, and Dibbits 2007, p. 8, fig. 18, on reshapings of the left forearm.

24. See Wheelock 1995, pp. 69–70, fig. 48, and Wheelock in Washington–The Hague 1995–96, p. 110, where the dark, rectangular form is considered "possibly a map." As noted in Dibbits 2007, p. 8, a map would be more expected "in the living quarters of the well-to-do middle classes." In the infrared reflectogram, the form resembles a mantelpiece, as noted by Dibbits. What he describes as "rather amorphous shapes to the left of the woman's head" and as perhaps "part of an object that once hung there" could be the supporting bracket and molding of a mantelpiece.

25. See Wheelock 1995, pp. 70–71, fig. 49; Wheelock in Washington–The Hague 1995–96, p. 110, fig. 2; and Dibbits 2007, p. 8, fig. 19.

26. Wheelock in Washington–The Hague 1995–96, p. 110, on space, and Dibbits 2007, p. 8, on design.

27. Wheelock 1981, pp. 32, 76, fig. 29, and Wheelock 1987, pp. 410–11, fig. 21, following Mayer-Meintschel 1978–79.

28. See, most recently, Liedtke 2007, p. 871, figs. 250, 251, and Liedtke 2008, p. 67, fig. 4b.

29. See Franits 1993, p. 47, where this translation is offered and Van Loo's picture discussed.

30. Dibbits (2007, p. 13n15) rightly rejects the suggestion made by Wheelock (1995, p. 71; and in Washington–The Hague 1995–96, p. 110) that, in accordance with an emblem by Roemer Visscher, the foot warmer stands for constancy in love. The actual Delft tile reproduced here (fig. 15) was published in connection with *The Milkmaid* in Nevitt 2001, p. 100, fig. 42, where the Cupid is thought to suggest "more pleasurable activities" than household chores.

31. See Washington–Boston 1983, no. 26, citing Wuyts 1974–75.

32. Becker (1624) 1972, fol. Fv. The original Dutch is quoted and a different English translation provided in Amsterdam 1997, pp. 261, 263n6.

33. See Amsterdam 1997, no. 21, for most of the points in this paragraph.

34. For a fuller discussion of Rembrandt's print and related works, see Amsterdam–London 2000–2001, no. 53.

35. See Liedtke 2007, pp. 988–91, with numerous references to iconographic literature.

36. On Beuckelaer's *The Four Elements*, see Campbell 2002, where, however, the meaning of this picture and aspects of the three others are misunderstood.

37. See Grosjean 1974, p. 128, and Dixon 1995, pp. 117–18.

38. Jan Steen's domestic comedies, such as *The Dissolute Household* in the Metropolitan Museum (see Liedtke 2007, pp. 841–44), occasionally show the man of the house in what would be (if anyone but the viewer saw it) a compromising encounter with a maid. But his subjects derive from the theater, popular proverbs, and the art world (Steen himself plays the guilty party) and cannot be considered scenes of modern life like those of Ter Borch, Vermeer, and so on. Similarly, surrogates such as the dandified officer seen with an implausible shopgirl (she wears an ermine-trimmed jacket) in Van Mieris's *The Cloth Shop*, of 1660 (Kunsthistorisches Museum, Vienna), are not comparable. However, the subject of a gentleman meeting a maid going to market is found in a popular pair of statuettes by the French sculptor Barthélemy Prieur (ca. 1536–1611): see Paris–New York–Los Angeles 2008–9, nos. 31, 32.

39. See Schama 1987, pp. 457–60.

40. Pepys 1985, p. 47.

41. See Montias 1989, doc. 439; Liedtke 2008, pp. 192–96.

42. For a more detailed account of Pieter van Ruijven, see Liedtke 2008, pp. 36–39, which is based mainly on Montias 1989, chap. 13, and other publications by Montias.

43. See Montias 1989, p. 247; Liedtke 2007, pp. 154, 155n18; and Liedtke 2008, p. 39.

44. Montias 1998, p. 95.

45. See New York–London 2001, p. 8, fig. 8, for the palace at Rijswijck, and pp. 10–12, 359–60, on hunting scenes painted for the court.

46. On the early works by Vermeer that are discussed in this paragraph, see the present writer's entries in New York–London 2001, nos. 64–66, and Liedtke 2008, nos. 1–3. The significance of the glass and lute neck in *The Procuress* is evidently pointed out for the first time in Liedtke 2000, p. 200. As with the erotic element in *The Milkmaid*, modern (that is, reverential) attitudes toward the artist evidently prevented earlier recognition of symbols that a contemporary viewer would not have missed.

47. In a diary entry of 1641, John Evelyn describes mural paintings by Van Couwenbergh in Frederick Hendrick's palace at Honselaarsdijck and

records that he "bought an excellent drollery" by the same artist. This was almost certainly one of the painter's Caravaggesque bordello scenes, which date back to the 1620s (see New York–London 2001, pp. 10 [on Evelyn] and 366, fig. 279). Prodigal Son pictures by Jan Sanders van Hemessen (1519–1559) are among the Flemish antecedents.

48. On the question of Vermeer's unknown teacher, see Liedtke 2008, pp. 16, 20–22.

49. See, for example, Van Aelst's still life of 1650 in the Warneford Collection (New York–London 2001, no. 2).

50. In his *Young Woman Stringing Pearls* (Musée Fabre, Montpellier; Liedtke 2008, p. 45, fig. 33).

51. For these and many of the following details, see Ben Broos in Washington–The Hague 1995–96, pp. 54–55 (on "Amsterdam amateurs"), 111–12 (on owners of *The Milkmaid*), 143 (on early owners of *Woman with a Balance*).

52. On the Van Winter collection, see Priem 1997.

53. On the Six collection sale to the Rembrandt Society and its public debate, see Edwin Buijsen's article "The Battle against the Dollar," in The Hague–San Francisco 1990–91, pp. 65–69.

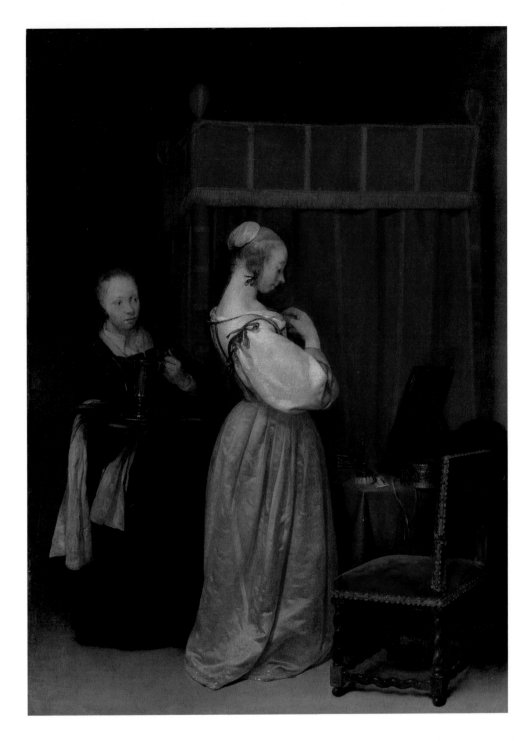

GERARD TER BORCH
(Zwolle 1617–1681 Deventer)

1. *A Young Woman at Her Toilet with a Maid,* ca. 1650–51

Oil on wood, 18¾ × 13⅝ in. (47.5 × 34.5 cm)

The Metropolitan Museum of Art, Gift of J. Pierpont Morgan, 1917
17.190.10

As a young painter in the early 1650s, Vermeer must have been impressed not only by Ter Borch's subjects, drawn from the upper crust of middle-class society, but also by his refined style, his worldly experience (he had lived in London and traveled to Italy and probably to Spain), and his success with patrons at the Dutch court in the neighboring city of The Hague. In April 1653, Vermeer and Ter Borch witnessed a testimony together in Delft. The notary was also an important art collector, Willem de Langue.

The Morgan panel, of about 1650–51, is one of the earliest works by Ter Borch to treat the type of subject that became Vermeer's specialty. A young woman admires herself in a mirror as her maid stands by with a silver basin and pitcher. Viewers of the time would have recognized that the traditional theme of vanity is here vividly brought to life, much as satins, silks, and velvets are rendered with exquisite virtuosity.

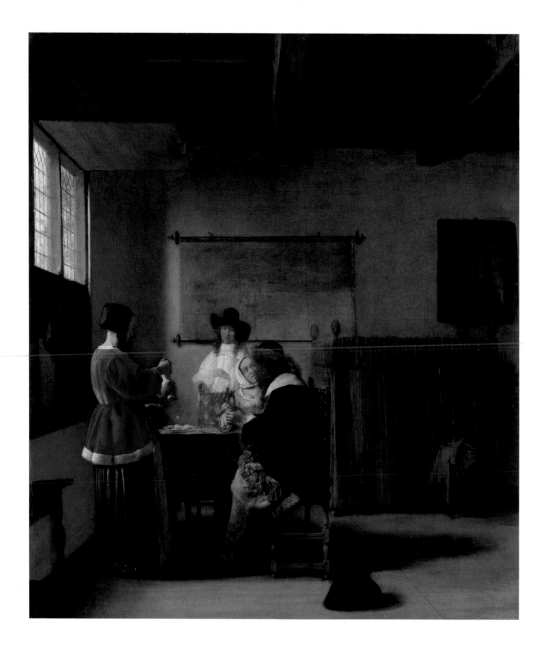

Pieter de Hooch

(Rotterdam 1629–1684 Amsterdam)

2. *The Visit*, ca. 1657

Oil on wood, 26¾ × 23 in. (67.9 × 58.4 cm)

The Metropolitan Museum of Art, H. O. Havemeyer Collection, Bequest of Mrs. H. O. Havemeyer, 1929 29.100.7

This panel was painted in Delft about 1657 and is one of the first works by De Hooch to employ linear perspective effectively. The artist's earlier dependence on figure groups, furniture, and contrasts of light and shadow to suggest three-dimensional space is still evident here, incongruously in the case of the under-scaled bed. Hints of De Hooch's association with Vermeer are found in the study of light on the woman to the left (compare the cavalier in fig. 5) and in her reflection in the window (compare fig. 4). In 1866, Thoré-Bürger paid this "superbe tableau" the compliment of attributing it to Vermeer, whom the French art critic was in the process of "discovering" in a celebrated series of articles.

Vermeer was making similar but bolder progress in constructing interior space at about the same time: the additive filling of voids found in *A Maid Asleep* (Pl. 6) is replaced by an illusionistic corner of space in *The Letter Reader* (fig. 4), where the intersection of walls is handled somewhat as it is here. De Hooch's grouping of courting couples—the men have recently arrived, to judge from the man's hat on the floor if not his attitude—and perhaps the shadowy and atmospheric environment recall paintings by Gerard ter Borch dating from the early to mid-1650s (see Pl. 1). But distinctive of De Hooch himself, and interesting for Vermeer, is the use of daylight and transparent shadows for the sense of space and suggestion of mood (compare Vermeer's *Woman with a Lute*; Pl. 8). De Hooch would soon depict more luxurious rooms and superficially more polite behavior than appear in paintings such as this important transitional work.

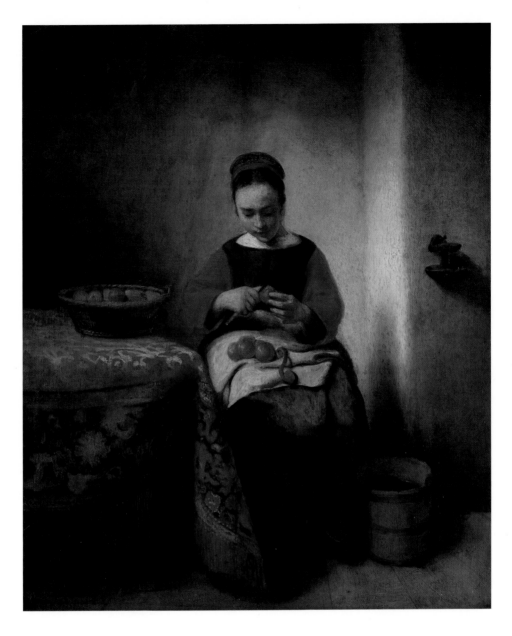

NICOLAES MAES
(Dordrecht 1634–1693 Amsterdam)

3. *Young Woman Peeling Apples*, ca. 1655

Oil on wood, 21½ × 18 in. (54.6 × 45.7 cm)

The Metropolitan Museum of Art, Bequest of Benjamin Altman, 1913
14.40.612

Maes studied with Rembrandt in Amsterdam during the early 1650s and then returned to his native Dordrecht, where he painted domestic scenes like this one of about 1655. Soft light and shadows, inspired by Rembrandt's paintings of the 1640s, are employed to create an intimate space and a peaceful mood. Like Vermeer in *The Milkmaid*, Maes shows a maid concentrating with contentment on a daily task. Dutch writers of the time, such as Jacob Cats, would have commended the young woman's modesty and diligence, although their usual heroine was a housewife (as in Metsu's *A Woman Seated at a Window*; Pl. 4). The use of a table and vessels in this composition to add presence and stability to the isolated figure bears comparison with the arrangement in *The Milkmaid*, where the foot warmer could be said to take on the space-marking function here served by the oil lamp.

GABRIËL METSU

(Leiden 1629–1667 Amsterdam)

4. *A Woman Seated at a Window*, ca. 1661

Oil on wood, 10⅞ × 8⅞ in. (27.6 × 22.5 cm)

Signed (bottom center): G. Metsu

The Metropolitan Museum of Art, The Jack and Belle Linsky
Collection, 1982 1982.60.32

This type of composition, popularized in Leiden by Gerrit Dou
(1613–1675), was called a *nisstuk* or *vensternis* ("niche piece" or
"window niche") in the seventeenth century. The format—nearly
always employed on a small scale—created the impression of
peeking into private homes and heightened the sense of illu-
sionistic space. Vermeer was especially responsive to Leiden
painters in the period he painted *The Milkmaid*, about 1657–58.
More than Dou and Frans van Mieris (1635–1681), Metsu shares
with the Delft artist a naturalistic description of daylight and a cor-
responding tendency to soften contours and generalize modeling.

The Linsky picture pays routine tribute to domestic virtue
(compare Maes's *Young Woman Peeling Apples*; Pl. 3). Motifs such
as the birdcage and the "fruitful vine by the side of thine house"
(from Psalm 128) indicate that the woman is happily confined in
her home and attached to a husband. The book on the window-
sill may be religious or secular but must, in this context, reflect
well on the woman's character. Dutch viewers of the day liked
to discover in pictures, in addition to delightful illusion, the advo-
cation of beliefs to which they already subscribed.

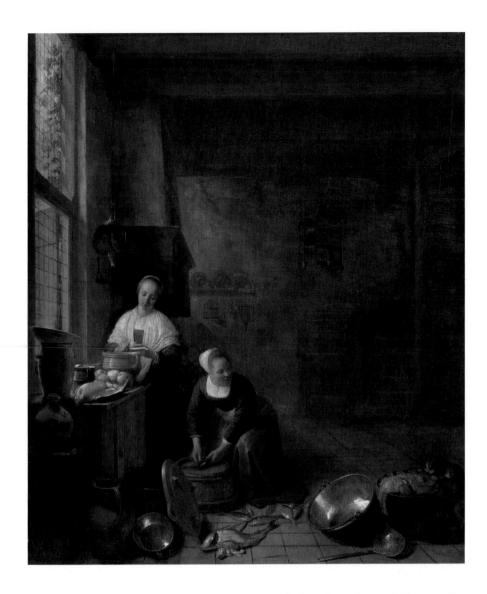

HENDRICK SORGH

(Rotterdam 1609/11–1670 Rotterdam)

5. *A Kitchen*, ca. 1643

Oil on wood, 20½ × 17⅜ in. (52.1 × 44.1 cm)

The Metropolitan Museum of Art, Gift of Henry G. Marquand, 1889
89.15.7

Sorgh painted a number of kitchen scenes similar to this one
during the 1640s in his native Rotterdam, the port city a short
distance southeast of Delft. The picture is thinly painted and
has suffered some wear, so that the location of the rear wall is
no longer clarified by a shelf and kitchen utensils (seen beyond
the fireplace), a door, and the spiral staircase to the right. The
arrangement of interior space in this composition, with its
abruptly receding wall and window to the left and openness to
the right, follows a pattern that may be traced back through
many variations to earlier decades, especially in the southern
part of Holland and in Antwerp. But artists such as Sorgh, his
fellow Rotterdammer Ludolf de Jongh, Pieter de Hooch (who
moved from Rotterdam to Delft about 1654–55), and Vermeer

made the scheme increasingly naturalistic, adopting a closer
vantage point, giving greater emphasis to the figures, and filling
the interior with convincing daylight and atmosphere (compare
The Visit, painted by De Hooch about 1657; Pl. 2).

In addition to his intense interest in direct observation, Ver-
meer had a quick eye for artistic conventions and their intended
effects. The composition of *The Milkmaid* could be described as
similar to the lower left corner of this picture by Sorgh (see the
detail, fig. 7), with the kneeling maid and objects in the fore-
ground eliminated. In our essay on Vermeer's painting, the rep-
utation of kitchen maids for amorous dalliance is discussed and
sexual symbols noted: fish and fowl as phallic forms, with pots
and jugs as their feminine counterparts. In an earlier state of
this picture (as revealed in an infrared reflectogram) Sorgh
included a young man in the right foreground, offering his fish
to the pretty maids (not unlike the man offering a bird in Peter
Wtewael's *Kitchen Scene*; fig. 18). Sorgh's repainting could be
compared with Vermeer's later practice of self-editing (as seen
especially in *A Maid Asleep*; Pl. 6), in which obvious motifs become
subtle intimations.

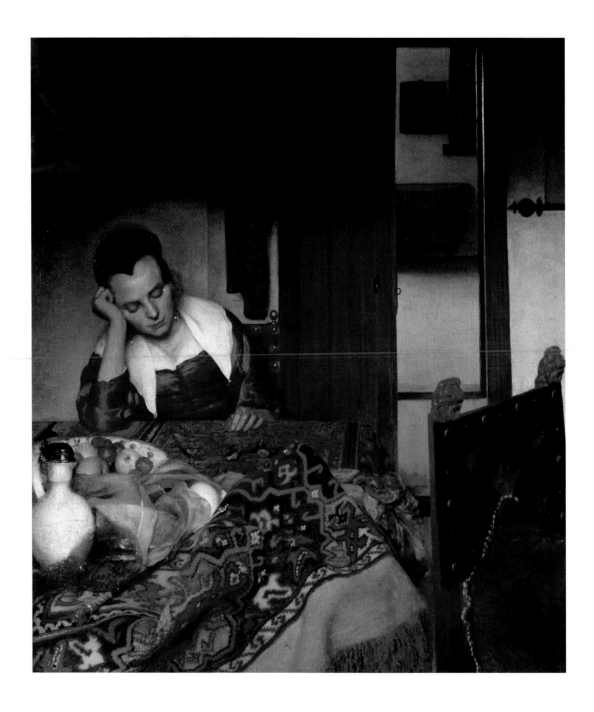

JOHANNES VERMEER
(Delft 1632–1675 Delft)

6. *A Maid Asleep*, ca. 1656–57

Oil on canvas, 34½ × 30⅛ in. (87.6 × 76.5 cm)

Signed (left, above the figure's head): I·VMeer·[VM in monogram]

The Metropolitan Museum of Art, Bequest of Benjamin Altman, 1913

14.40.611

This canvas of about 1656–57 dates from shortly before *The Milkmaid* but differs considerably in style, mainly because Vermeer was looking to the former Rembrandt pupil Nicolaes Maes for inspiration (see Pl. 3) rather than to painters of more polished genre scenes such as Gerard ter Borch (see Pl. 1) and the Leiden master Gerrit Dou (1613–1675) and his followers. *A Maid Asleep* is the earliest known picture by Vermeer to have been owned by his Delft patron Pieter Claesz van Ruijven (1624–1674), who by the early 1670s had acquired as many as twenty-one paintings by the artist.

The subject is an overdressed servant (ranking higher than a kitchen maid) who, to judge from the fruit and wine and certain symbols on the table, has been entertaining a male visitor (a radiograph reveals such a figure in the rear room). The picture to the upper left represents "Cupid unmasked" and refers to the woman's romantic thoughts and smiling lips. The close vantage point, the unguarded figure, and the extraordinary description of daylight tempt the viewer to intrude, but physical and psychological barriers prevent it.

JOHANNES VERMEER

(Delft 1632–1675 Delft)

7. *Young Woman with a Water Pitcher,* ca. 1662

Oil on canvas, 18 × 16 in. (45.7 × 40.6 cm)

The Metropolitan Museum of Art, Marquand Collection, Gift of
Henry G. Marquand, 1889 89.15.21

In his early paintings Vermeer addressed the theme of feminine
virtues in a mythological and a religious work (figs. 22, 23), in a
bordello scene (fig. 24), and in *A Maid Asleep* (Pl. 6). The women
in those pictures are all servants in some respect, as is the figure
in *The Milkmaid*. About 1657 the artist turned to the subject of
courtship (as in the *Cavalier and Young Woman;* fig. 5) and lovely
young women discovered alone with their thoughts in domestic

surroundings (the earliest example is *The Letter Reader* in Dresden;
fig. 4). It was certainly the example of Gerard ter Borch (see
Pl. 1) who first pointed Vermeer in the direction of his most
typical subjects and who encouraged his sympathetic interpreta-
tions of feminine character.

The Marquand canvas dates from about 1662 and marks an
early phase of Vermeer's mature style, which (partly in contrast
to *The Milkmaid*) treats forms and space in the optical terms of
light, shadow, tonal and color values, and soft focus rather than
drawing and modeling. The subject is an ideal woman in an
ideal home, where beauty, luxury, and tranquility coexist. A jew-
elry box and a map suggest worldliness, but the silver-gilt basin
and pitcher would have been recognized as a traditional symbol
of purity. Virtue is also implied by the white linen scarfs worn
over the head and shoulders, usually during the morning toilette.

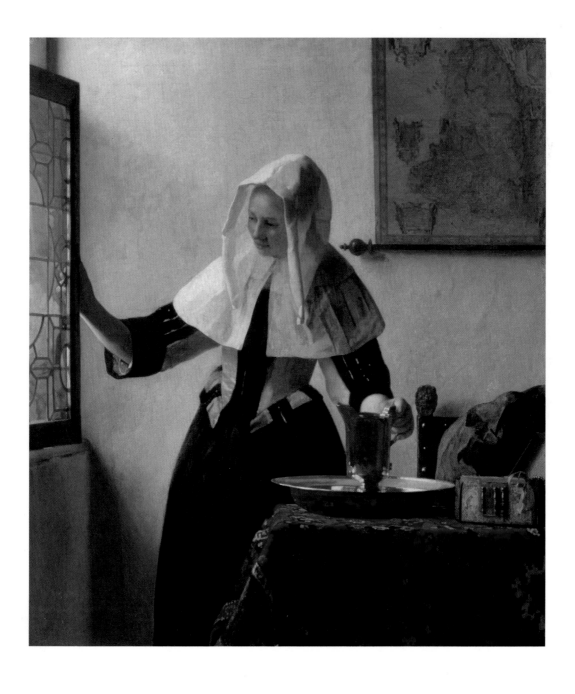

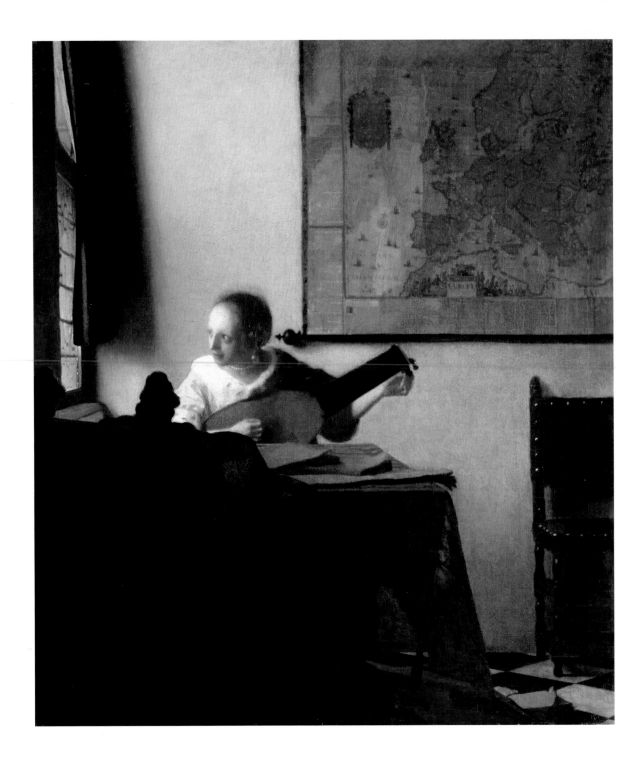

JOHANNES VERMEER
(Delft 1632–1675 Delft)

8. *Woman with a Lute*, ca. 1662–63

Oil on canvas, 20¼ × 18 in. (51.4 × 45.7 cm)
The Metropolitan Museum of Art, Bequest of Collis P. Huntington,
1900 25.110.24

This picture probably dates from slightly later than the *Young Woman with a Water Pitcher* (Pl. 7) and reveals the more muted and uniform palette that Vermeer employed in works of about 1663–65 (for example, the *Woman with a Pearl Necklace*, in the Gemäldegalerie, Berlin, and other "pearl pictures"). Again the figure is framed by rectangular elements (table, map, and window), but to almost impatient rather than peaceful effect. The young woman, dressed for company, looks eagerly out the window as she tunes her lute (an act that alludes to temperance). The viola da gamba on the floor and the songbooks on the table suggest that she awaits a male visitor. An enormous pearl earring (or an imitation made of glass) and pearl necklace identify the woman as a modern-day Venus in search of Adonis.

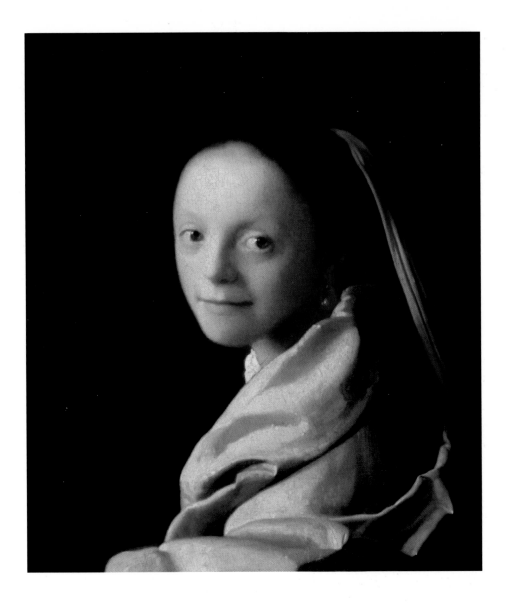

JOHANNES VERMEER
(Delft 1632–1675 Delft)

9. *Study of a Young Woman*, ca. 1665–67

Oil on canvas, 17½ × 15¾ in. (44.5 × 40 cm)

Signed (upper left): IVMeer. [IVM in monogram]

The Metropolitan Museum of Art, Gift of Mr. and Mrs. Charles Wrightsman, in memory of Theodore Rousseau Jr., 1979 1979.396.1

This haunting picture from the Wrightsman Collection dates from about 1665–67, when Vermeer painted two similar works, *Girl with a Pearl Earring* (Mauritshuis, The Hague) and *Girl with a Red Hat* (National Gallery of Art, Washington, D.C.). These small works were intended not as portraits but as studies of imaginary characters (even when real models were employed), often with curious features, expressions, and costumes, in this case a silk or satin fabric simply wrapped around the shoulders, a silk scarf, and a large earring. Inventories of the period usually describe pictures of this type as *tronies*, meaning "faces" or "visages." In the 1696 sale of paintings owned by Jacob Dissius, the son-in-law of Vermeer's patron Pieter van Ruijven, "a *tronie* in antique [meaning outdated] dress, uncommonly artful," was listed as by Vermeer, with two more of "the same." And two *tronies* "painted in Turkish fashion" were still in the artist's possession at his death. "Turkish" would be a more appropriate description of the costume in the *Girl with a Pearl Earring*, since it combines a turban with contemporary dress, whereas "antique" is suggested by the drapery in the Wrightsman picture and there is nothing especially "oriental" (or Dutch) about the yellow scarf.

Describing the behavior of light on shiny materials was at the time considered a test of artistic virtuosity. Here, the radiant reflections and rhythms in the drapery would have been admired by connoisseurs, while Vermeer's fellow painters would have noted the way the bare wrist intensifies the impression made by the face and the manner in which the eyes are enhanced by the glimpse of white cloth at the neck. In style and subject this painting stands at a greater distance from *The Milkmaid* than might be expected from the passage of eight or nine years, but the theme of intriguing women continues.

Johannes Vermeer
(Delft 1632–1675 Delft)

10. *Allegory of the Catholic Faith*, ca. 1670–72

Oil on canvas, 45 × 35 in. (114.3 × 88.9 cm)

The Metropolitan Museum of Art, The Friedsam Collection,
Bequest of Michael Friedsam, 1931 32.100.18

Despite its similarity in composition to Vermeer's more admired picture *The Art of Painting*, of about 1666–68 (Kunsthistorisches Museum, Vienna), this allegorical work differs greatly in style and purpose. The earlier painting was intended as an extraordinary display of the artist's ability to invent (the studio we see is a lavish fiction) and execute an illusion of reality. Here no such deception is attempted. Rather, the picture describes an abstract concept in a corresponding style of painting, one far removed from that of other late works, to say nothing of pictures dating from the 1660s (see Pls. 7–9).

The description of at least two objects in the picture, however, continues Vermeer's interest in direct observation: the terrestrial globe and the glass ball hanging from the ceiling. The lower sphere stands for the earth, which the Catholic faith dominates; the transparent globe symbolizes heaven. In the foreground a serpent (Satan) is crushed by Christ, cornerstone of the Church. Nearby is the apple of Original Sin, which required the sacrifice depicted in the background, in a known painting by Jacob Jordaens. On the table, which is covered to resemble an altar, a crucifix, a chalice, a long silk cloth (perhaps a priest's stole), and an unexpected crown of thorns refer to the sacrament of the Eucharist, which in Vermeer's day was celebrated by a Mass, or *missa*. Thus the large book is probably not a Bible but the *Missale Romanum*.

Vermeer converted to Catholicism shortly before his marriage in April 1653. His mother-in-law was closely associated with the small Jesuit community in Delft, which had a "hidden church" or chapel in a private house nearby. The scale and decoration of the room in this picture suggest such a setting and thereby alludes to the circumstances of Catholic worship in the Protestant Dutch Republic. Such an intellectual rather than devotional subject indicates that the painting was commissioned by a private party and was not meant for contemplation in a church.

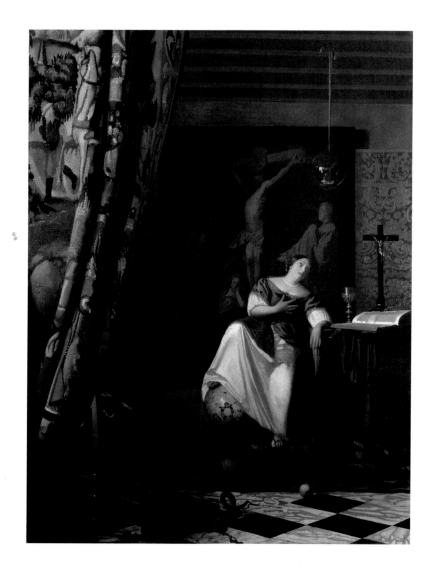

HENDRICK VAN VLIET
(Delft 1611/12–1675 Delft)

11. *Interior of the Oude Kerk, Delft*, 1660

Oil on canvas, 32½ × 26 in. (82.6 × 66 cm)

Signed and dated (in foreground, at base of column): H. van vliet / 1660

The Metropolitan Museum of Art, Gift of Clarence Dillon, 1976
1976.23.2

Like Emanuel de Witte (see Pl. 12), the Delft portraitist Hendrick van Vliet started painting views of the Oude Kerk (Old Church) in the early 1650s, following the lead of the older specialist Gerard Houckgeest (ca. 1600–1661). Pictures of this type were a new and distinctly Protestant art form, reflecting the fact that by 1600 the mostly Gothic churches of the northern Netherlands had been converted from Catholic to Calvinist use by stripping bare their "Popish" appointments and whitewashing the walls and columns. The center of worship became a pulpit at the side of the nave, from which the preacher would read scripture to a congregation gathered on chairs and stools.

The original appeal of such paintings was not only religious but aesthetic; they were often listed as "Perspectives" in seventeenth-century inventories. Van Vliet painted hundreds of views of the Oude Kerk and the Nieuwe Kerk in Delft, and several pictures of major churches in Gouda, The Hague, Leiden, and Utrecht.

EMANUEL DE WITTE
(Alkmaar ca. 1616–1692 Amsterdam)

12. *Interior of the Oude Kerk, Delft*, 165[0?]

Oil on wood, 19 × 13⅝ in. (48.3 × 34.5 cm)

Signed and dated (lower right): E·DE·Witte A 165[0?]

The Metropolitan Museum of Art, Purchase, Lila Acheson Wallace, Virgilia and Walter C. Klein, The Walter C. Klein Foundation, Edwin Weisl Jr., and Frank E. Richardson Gifts, and Bequest of Theodore Rousseau and Gift of Lincoln Kirstein, by exchange, 2001 2001.403

Originally a figure painter of modest ability, Emanuel de Witte turned to the new subject of local church interiors about 1650 in Delft, under the influence of the experienced architectural painter Gerard Houckgeest (ca. 1600–1661). Unlike his older colleague, he treated Gothic structures less in terms of solid forms than of space, light, and mood. While this focus on intangible elements suggests a spiritual environment, it also anticipates the optical approach of Vermeer. This view of the Oude Kerk was recorded from the south aisle, looking to the northeast. Despite the general impression of fidelity to the site, De Witte has eliminated some of the major motifs that he would have seen in the building and he has modified architectural elements and altered the overall effect of space. The church's pulpit was dropped from the nearest column and replaced by an epitaph featuring putti, which actually hung on one of the columns seen in the background. This motif, the freshly dug grave in the foreground, and the contrast between the boys (budding artists) and the old men remind one that everyday life is fleeting while the Church promises life after death.

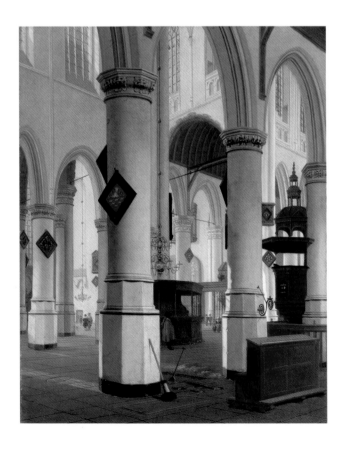

Bibliography

Amsterdam 1997
Mirror of Everyday Life: Genreprints in the Netherlands, 1550–1700. Exhibition, Amsterdam, Rijksprentenkabinet, Rijksmuseum, 1997. Catalogue by Eddy de Jongh and Ger Luijten; translated by Michael Hoyle. Amsterdam and Ghent, 1997.

Amsterdam–London 2000–2001
Rembrandt the Printmaker. Exhibition, Amsterdam, Rijksprentenkabinet, Rijksmuseum, and London, The British Museum, 2000–2001. Catalogue by Erik Hinterding, Ger Luijten, and Martin Royalton-Kisch, with contributions by Marijn Schapelhouman et al. London, Amsterdam, and Zwolle, 2000.

Becker (1624) 1972
Jochen Becker, ed. *Incogniti scriptoris Nova poemata: Nieuwe Nederduytsche gedichten ende raedtselen*. Reprint of the 1624 ed. Soest, 1972.

Campbell 2002
Lorne Campbell. "Beuckelaer's *The Four Elements*: Four Masterpieces by a Neglected Genius." *Apollo*, no. 480 (February 2002), pp. 40–46.

Dibbits 2007
Taco Dibbits. "The Milkmaid." In *Milkmaid by Vermeer and Dutch Genre Painting: Masterworks from the Rijksmuseum Amsterdam*, pp. 4–13. Tokyo, 2007. English supplement to *Ferumeru "Gyunyu o sosogu onna" to Oranda fuzokuga ten: Amusuterudamu kokuritsu bijutsukan shozo*. Exh. cat., Tokyo Shinbun. Tokyo.

Dixon 1995
Laurinda S. Dixon. *Perilous Chastity: Women and Illness in Pre-Enlightenment Art and Medicine*. Ithaca, N.Y., and London, 1995.

Franits 1993
Wayne E. Franits. *Paragons of Virtue: Women and Domesticity in Seventeenth-Century Dutch Art*. Cambridge, New York, and Melbourne, 1993.

Grosjean 1974
Ardis Grosjean. "Toward an Interpretation of Pieter Aertsen's Profane Iconography." *Konsthistorisk tidskrift* 43 (1974), pp. 121–43.

The Hague–San Francisco 1990–91
Great Dutch Paintings from America. Exhibition, The Hague, Royal Cabinet of Paintings Mauritshuis, and San Francisco, The Fine Arts Museums of San Francisco, 1990–91. Catalogue by Ben Broos et al. The Hague and Zwolle, 1990.

Krempel 2000
León Krempel. *Studien zu den datierten Gemälden des Nicolaes Maes (1634–1693)*. Petersberg, 2000.

Lasius 1992
Angelika Lasius. *Quiringh van Brekelenkam*. Doornspijk, 1992.

Liedtke 2000
Walter Liedtke. *A View of Delft: Vermeer and His Contemporaries*. Zwolle, 2000.

Liedtke 2007
Walter Liedtke. *Dutch Paintings in The Metropolitan Museum of Art*. 2 vols. New York, 2007.

Liedtke 2008
Walter Liedtke. *Vermeer: The Complete Paintings*. Antwerp, 2008.

Van Mander 1604
Karel van Mander. *Het Schilder-Boeck* Haarlem, 1604.

Mayer-Meintschel 1978–79
Annaliese Mayer-Meintschel. "Die Briefleserin von Jan Vermeer van Delft: Zum Inhalt und zur Geschichte des Bildes." *Jahrbuch der Staatlichen Kunstsammlungen Dresden* 11 (1978–79), pp. 91–99.

Montias 1989
John Michael Montias. *Vermeer and His Milieu: A Web of Social History*. Princeton, 1989.

Montias 1998
John Michael Montias. "Recent Archival Research on Vermeer." In *Vermeer Studies*, edited by Ivan Gaskell and Michiel Jonker, pp. 93–109. Studies in the History of Art, 55. Washington, D.C.: National Gallery of Art, 1998.

Nevitt 2001
H. Rodney Nevitt Jr. "Vermeer on the Question of Love." In *The Cambridge Companion to Vermeer*, edited by Wayne E. Franits, pp. 89–110. Cambridge, 2001.

New York–London 2001
Vermeer and the Delft School. Exhibition, New York, The Metropolitan Museum of Art, and London, The National Gallery. Catalogue by Walter Liedtke et al. New York, 2001.

Paris–New York–Los Angeles 2008–9
Cast in Bronze: French Sculpture from Renaissance to Revolution. Exhibition, Paris, Musée du Louvre; New York, The Metropolitan Museum of Art; Los Angeles, J. Paul Getty Museum; 2008–9. Catalogue edited by Geneviève Bresc-Bautier and Guilhem Scherf, with James David Draper (English ed.). Paris, 2009.

Pepys 1985
Samuel Pepys. *The Shorter Pepys*. Selected and edited by Robert Latham. Berkeley, 1985.

Priem 1997
Ruud Priem. "The 'most excellent collection' of Lucretia Johanna van Winter: The Years 1809–22, with a Catalogue of the Works Purchased." *Simiolus* 25 (1997), pp. 103–235.

Rand 1998
Harry Rand. "Wat maakte de 'Keukenmeid' van Vermeer?" *Bulletin van het Rijksmuseum* 46 (1998), pp. 275–78, and 349–51 (English version).

Robinson 1974
Franklin W. Robinson. *Gabriel Metsu (1629–1667): A Study of His Place in Dutch Genre Painting of the Golden Age*. New York, 1974.

Schama 1987
Simon Schama. *The Embarrassment of Riches: An Interpretation of Dutch Culture in the Golden Age*. New York, 1987.

Washington–Boston 1983
The Prints of Lucas van Leyden and His Contemporaries. Exhibition, Washington, D.C., National Gallery of Art, and Boston, Museum of Fine Arts, 1983. Catalogue by Ellen S. Jacobowitz and Stephanie Loeb Stepanek. Washington, D.C., 1983.

Washington–The Hague 1995–96
Johannes Vermeer. Exhibition, Washington, D.C., National Gallery of Art, and The Hague, Mauritshuis, 1995–96. Catalogue edited by Arthur K. Wheelock Jr., with contributions by Albert Blankert et al. The Hague, Washington, D.C., and Zwolle, 1995.

Wheelock 1981
Arthur K. Wheelock Jr. *Jan Vermeer*. New York, 1981.

Wheelock 1987
Arthur K. Wheelock Jr. "Pentimenti in Vermeer's Paintings: Changes in Style and Meaning." In *Holländische Genremalerei im 17. Jahrhundert: Symposium Berlin 1984*, edited by Henning Bock and Thomas W. Gaehtgens, pp. 385–412. Jahrbuch Preussischer Kulturbesitz, Sonderband 4. Berlin, 1987.

Wheelock 1995
Arthur K. Wheelock Jr. *Vermeer and the Art of Painting*. New Haven and London, 1995.

Wuyts 1974–75
Leo Wuyts. "Lucas van Leydens 'Melkmeid': Een proeve tot ikonologische interpretatie." *De gulden passer* 52–53 (1974–75), pp. 441–53.